The Winterthur Garden Guide:
COLOR FOR EVERY SEASON

by

Linda Eirhart

Based on
The Winterthur Guide to Color in Your Garden
by Ruth N. Joyce

WINTERTHUR MUSEUM, GARDEN & LIBRARY
in association with
Temple University Press

Winterthur gratefully acknowledges the following for their generous support of this publication:

Georgina M. Bissell · Katharine P. Booth · Alice Cary Brown · Louisa C. Duemling
Edric Foundation · John and Dolly Fisher · Dan Holloway and Cynthia Hewitt
Maureen Cawley Rhodes · Coleman and Susan Townsend
The Winterthur Garden & Landscape Society

WINTERTHUR MUSEUM, GARDEN & LIBRARY
5105 Kennett Pike
Winterthur, DE 19735
800.448.3883 / 302.888.4600
winterthur.org

EDITOR Onie Rollins

DESIGNER Karla Cushman, *studiocushman.com*

PHOTOGRAPHY Erica Anderson, Andrew Bunting, Jenny Rose Carey, Mac Edwards, Linda Eirhart,
Liz Farrell, Ruth Joyce, ©Larry Lederman, Jeannette Lindvig, Carol Long, Rhoda Maurer,
Lois Mauro, Karen Steenhoek, University of Delaware Botanic Gardens

ISBN 978-0-912724-77-5
Printed in China

Eirhart, Linda, author. | Henry Francis du Pont Winterthur Museum, issuing body.
The Winterthur garden guide : color for every season / by Linda Eirhart ;
with an introduction by Ruth N. Joyce.
Winterthur book.
Winterthur, DE : Winterthur Museum, Garden & Library in association with
Temple University Press, [2019] | Series: A Winterthur book
LCCN 2018057193 | ISBN 9780912724775 (hardcover)
LCSH: Gardens--Delaware. | Henry Francis du Pont Winterthur Museum Gardens (Del.)
LCC SB466.U7 H466 2019 | DDC 635.09751--dc23 LC record available at *https://lccn.loc.gov/2018057193*

Contents

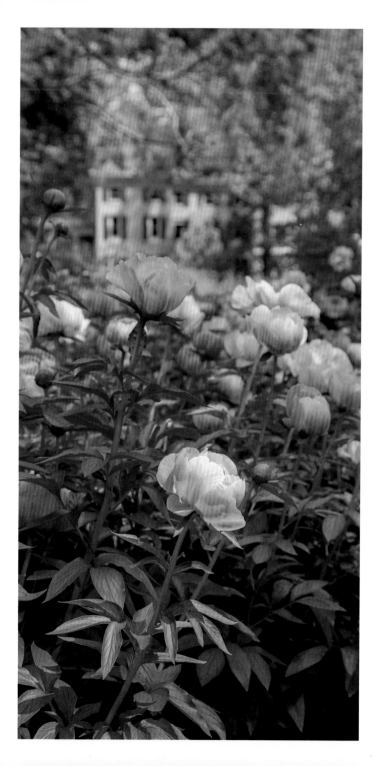

Foreword

The Winterthur garden is a gem. If you have not had the opportunity to visit, particularly in the spring, I can think of no better way to be guided through this naturalistic wonder than by the words of Linda Eirhart and Ruth Joyce. I am fond of saying that Winterthur is easy to enjoy but difficult to understand. H. F. du Pont's use of color is dramatic as well as nuanced; tasteful, but sometimes overwhelming. Through their careful documentation and analysis of the garden throughout the seasons, Linda and Ruth help you understand how the magician worked his magic. H. F. du Pont didn't explain what he was doing; he let the garden speak for itself. As stewards of this legacy, we are grateful for his genius.

Whether you are a seasoned gardener or a rank beginner, the information found in the following chapters provides the tools for replicating the beauty of Winterthur in your own garden. My thoughts mirror those of du Pont, who noted in his Foreword to the 1967 publication *Winterthur in Bloom*, "My work is in the garden; the story... leaves little for me to say except that I hope everyone will enjoy the book as much as I have."

Chris Strand, *Brown Harrington Director of Garden & Estate*

Acknowledgments

This book owes its foundation to the work of former Winterthur garden guide and researcher Ruth Joyce. Ruth was affiliated with Winterthur for some twenty years and in 2004 authored the eminently popular *Winterthur Guide to Color in Your Garden*. That gardeners' companion provided the reader with the essentials for replicating the essence of the Winterthur garden at home and, indeed, forms the core of the current volume, which highlights new photography, updated information, and discoveries for every season. Our sincere thanks to Ruth for providing the solid foundation upon which to build a fresh look at Henry Francis du Pont's masterpiece.

Thanks as well to Winterthur editor Onie Rollins for her support, guidance, and dedication to the project. Our deepest appreciation also to Karla Cushman for her considerable talents in designing a book that can inspire and inform all our endeavors in the garden.

Thank you to Julia Eppes for ensuring we had an accurate version to begin updating text and for thoughtful questions and suggestions. Volunteers Jeannette Lindvig and Lois Mauro have photographed the garden over the years and have contributed the majority of images so critical in illustrating Mr. du Pont's use of color. Erica Anderson was a joy to work with and provided close-up shots featuring the beauty of individual flowers. Additional images were provided by staff, friends, and volunteers.

For more than ten years, volunteers Walter Hipple and Pauline Myers have braved the cold, heat, and rain to create a weekly garden report that records what is in flower or fruit. These fact-based references are essential for anyone contemplating research in the garden. Special thanks to Patti Pleva, who coordinates their work and that of the volunteer garden photographers.

The garden and estate staff make it possible to continue telling the story of the Winterthur garden through their knowledge, care, and dedication. Thanks to Chris Strand, Madeline Banks, Kevin Braun, Marlin Dise, Leigh Donnelly, Suzanne French, Joe Lazorchak, Carol Long, Jim Pirhalla, Rob Plankinton, Patti Pleva, Frank Quinnette, John Salata, Lori Schnick, David Schurr, Susan Sibley, Michelle Stapleford, Kevin Stouts, Jessica Tsakiris, Dannie Wright, Cecilia Davidson, Samantha Marcus, and Frank Splane for their support and assistance.

Finally, thank you to Michael, Jason, Michelle, and Katie for their love, support, and suggestions and to Ed and Betty Grewe for a lifetime of love and encouragement.

Early peonies and greenhouses.

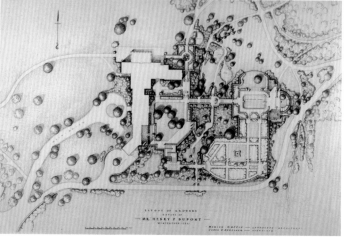

Introduction

Color, to Henry Francis du Pont, was a "vast field in itself" and, in the garden, "the thing that really counts more than any other." By 1962 du Pont had been gardening for sixty years, and the Garden Club of America had recently named him "perhaps the best gardener this country has ever produced." At his family home, his beloved country estate called Winterthur, he created a garden of surpassing beauty that in its complexity and coherence is a marvel of ingenuity. Plants bloom almost continuously throughout the year, with outstanding areas of color coming into focus in a well-planned sequence. In turn, each area melds seamlessly with its neighbors to form a unified whole. Such sequencing and continuity did not come about without a great deal of work and planning. All told, du Pont devoted some seventy years, a labor of love to be sure, to creating his world-class garden. Today Winterthur's talented horticulturists, with deep respect and devotion, continue to preserve, renew, and amplify his design.

What can we as gardeners, from enthusiastic novices to the more advanced, learn from this beautifully planned landscape and from its creator? Surely many things. In presenting this publication, my

colleagues at Winterthur and I offer some of the accumulated wisdom that the garden represents. Winterthur's plants are introduced as they appear from month to month, grouped as they are in the garden. This organization brings together plants that bloom at the same time in colors that enhance one another. In addition to groupings, such plants as Virginia bluebells and wild phlox bloom throughout the property and, in their time, "carry the day." These are noteworthy and given their due. Genera such as magnolias, which appear in many places, are, for simplification, addressed together. Azalea Woods, the Sundial Garden, the bog of the Quarry Garden, the fish pools in the Glade Garden, and plantings around the Reflecting Pool round out the mix.

We present here practical plants that have stood the test of time, native and non-native, common and unusual. Through his indefatigable searching, H. F. du Pont found countless little-used plants that are both beautiful and easy to grow. Many appear in this guide. We also illustrate a number of du Pont's design principles. One in particular is soon apparent—there are no fussy mixtures. Scenes are instead painted in what landscape architect

William H. Frederick Jr. calls "broad, bold brush strokes" of color—partly because Winterthur is a vast estate and has been invested with plants in proportion to its size but also because this practice was very much a part of du Pont's aesthetic. Photographs presenting framed views show us that scenes are often made up of one color and its variations set against a background of greens and neutrals. Such groupings are infinitely peaceful and satisfying. When more than one color is used, we find that the colors are grouped pleasingly but with one color dominating.

Inherent in du Pont's nature were a love of beauty, an excellent sense of spatial relations, a penchant for noticing details, and a discriminating awareness of color. He credits much of the development of his talents to growing up among flowers, which if "really seen," he said, would help one appreciate proportion, detail, material, and color. With energy and perseverance, he combined these gifts with a well-organized approach to gardening.

H. F. du Pont had one habit that was particularly instrumental in his success—he was a lifelong, diligent

note-taker. He walked in his garden each day when he was in residence, seeing how his "children" were faring, what was in bloom, noticing what might be improved, what needed to be moved, and jotting it all down in a pocket notebook or hardcover diary. When he found a color combination that he liked in his or someone else's garden, or at a flower show, he wrote it down. When discovering a new plant, he noted not only the color, which he often related to something he knew (milk white, wax white, etc.), but also other details that were important to him. For daffodils, for instance, he would note the length and strength of the stems and the way the blossoms were held. This businesslike approach to gardening served him well.

Through this empirical but organized approach as well as continuous study, du Pont created his magnificent garden. Although few of us have the vast acres that Winterthur encompasses, we can apply du Pont's principles and color combinations on a smaller scale. The following pages provide abundant inspiration.

Using This Book

The Winterthur garden is arranged as a series of focal areas that take center stage one after another during the year. This guide follows a corresponding pattern. Plants in harmonizing colors that have the same bloom time are grouped here as they are in the garden. These areas have names such as March Bank, Winterhazel Walk, and Azalea Woods. A brief description introduces each area and places it in the proper seasonal timeframe; photographs show plant combinations as well as individual plants.

Hardiness zones are based on USDA zones and indicate where the plant will usually grow well. A zone in parentheses indicates a marginally safe zone for that plant since viability can vary due to microclimates, soils, and summer conditions, among other factors. Finally, the glossary provides a quick reference to unfamiliar terms you may encounter in the text.

Ruth N. Joyce

March Bank

East Terrace

WINTER
into SPRING

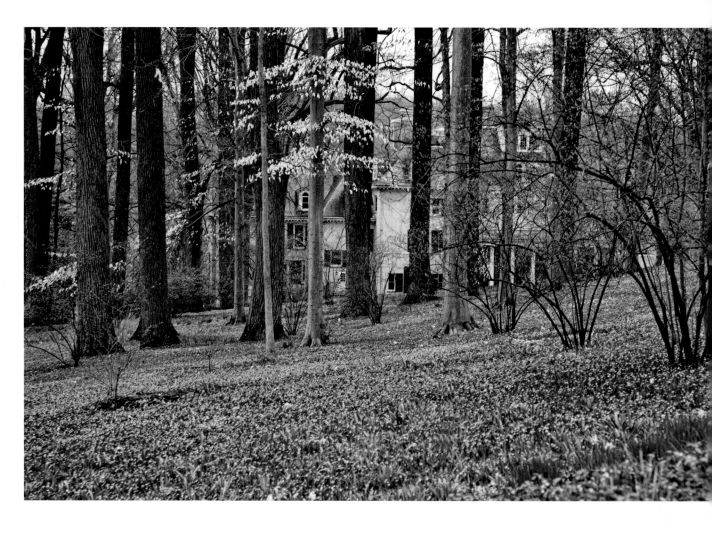

FINDING AND REPORTING THE FIRST FLOWERS OF THE NEW YEAR WAS A longstanding tradition in the du Pont family. Winterthur's March Bank celebrates this lifelong pleasure with hardy bulbs that defy cold weather to bring color and life to the winter scene. Begun in the early 1900s with a few thousands bulbs under a canopy of woodland trees, the March Bank is now a showcase for millions of winter-flowering bulbs that can also be found with additional flowering shrubs on the East Terrace near the house.

MARCH BANK

Late January to April

In January and February, the hardy garden visitor searches intently for the first flowers of the season. By March, the March Bank, with its acres of flowering bulbs, boldly proclaims the arrival of the new growing season. An encore effect ripples through the garden as the same colorful plants—some purposely planted or sown, some self-seeded—appear in smaller drifts and pockets. This repetition creates a sense of unity and makes Winterthur an exceptional early spring garden. The smaller groupings also suggest ways to bring the colors of the March Bank to our own gardens.

Begun in 1902, the March Bank is a superb example of the "Wild Garden" concept promoted by the nineteenth-century British gardener and writer William Robinson. In his words, the term "is applied essentially to the placing of perfectly hardy exotic plants in places and under conditions where they will become established and take care of themselves." Planted with minor bulbs, the March Bank has grown into an extensive naturalistic display. The first to flower are the giant snowdrops (*Galanthus elwesii*), diminutive bulbs

that create a green-and-white color scheme against the brown of fallen leaves or vestiges of snow. Being weather dependent like other minor bulbs, their exact bloom time will vary. Bright yellow is added to the mix with the appearance of Amur adonis (*Adonis amurensis*) and winter aconites (*Eranthis hyemalis*), both with round, multi-petal flowers that resemble large buttercups. Adonis will spread slowly in the garden, but winter aconites are splendid growers that readily self-sow once established, so you will want to avoid planting them by smaller, more delicate spring plants. A touch of lavender from an early crocus (*Crocus tommasinianus*) complements the yellows, creating a color scheme that du Pont would repeat through the seasons.

The white of this early display is enhanced and sustained on the March Bank and in nearby woodland areas with the later-flowering common snowdrop (*Galanthus nivalis*) and the spring snowflake (*Leucojum vernum*). Du Pont planted large drifts of the giant snowdrop, common snowdrop, and the spring snowflake but separate

Winter aconites welcome visitors to the March Bank.

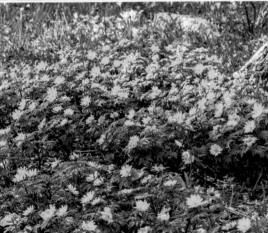

A drift of Adonis.

"Good with all the bulbs," said H. F. du Pont of this early-flowering dogwood tree, Cornus officinalis.

from one another. These separate mass plantings allow each of them to shine during their flowering period without the distraction of the fading flowers of the others.

To heighten and extend the yellow display, du Pont chose Japanese cornel dogwood *(Cornus officinalis)*, an understory tree whose yellow flowers begin to shine while the giant snowdrops and winter aconites are still flowering. As the snowdrops and aconites fade, this dogwood's flowers will continue to bloom while the March Bank transitions to a brilliant carpet of blue.

Primarily responsible for this azure phase is glory-of-the-snow (*Chionodoxa forbesii*), which spills over into secondary pools of color at some distance in the landscape. In some areas, Siberian squills (*Scilla siberica*) are planted with it and overlap somewhat in flowering time. Viewed closely, the lavender blue glory-of-the-snow and royal blue squills do not seem to harmonize; yet, interplanted in large numbers, in the style of H. F. du Pont, they create a delightful effect when they flower together. In some years, we see instead a neat succession, the squills emerging as the glory-of-the-snow wanes. Either plant is lovely by itself as well. They are excellent multipliers and will give years of pleasure as

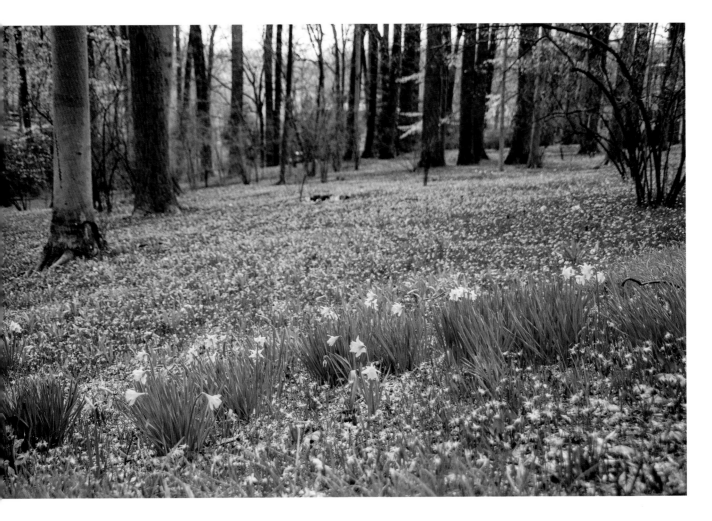

they increase, *Chionodoxa* spreading over wide areas and *Scilla* forming handsome clumps.

Sprinkled along the March Bank are several groups of soft yellow daffodils (*Narcissus*), just enough to heighten the sweep of blue by contrast. Purple and white Dutch hybrid crocus (*Crocus* hybrids) make their appearances,

while white bloodroot (*Sanguinaria canadensis*) arrives later. By the end of March, the bank is thick with the leaves of emerging Virginia bluebells, Italian windflowers, and other naturalized plants, holding promise of flowers to come. ⚘

Early-flowering daffodils brighten a drift of glory-of-the-snow.

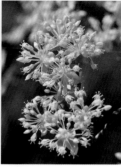

March Bank

In Your Garden

March Bank is an easy type of planting for the home gardener to emulate. The concept is simple: a few hardy plants that spread every year, producing carpets of color in early spring. A group of deciduous trees, especially on a slope, would provide the ideal setting for a mass planting; however, even a few minor bulbs near the entrance to your home can brighten a winter day. Other possible sites include pockets created by roots of trees, the front of a border, under shrubs, or in a rock garden. Many of these bulbs will also perform well in your lawn, as we will see on the East Terrace.

Adonis amurensis

· Amur adonis
· Ranunculaceae

ORIGIN
Japan and
Eastern Asia

ABOUT
Herbaceous perennial. Glossy, yellow, buttercup-like blossoms followed by ferny foliage that lasts until June. Needs 6 weeks of temperatures below 40°F to break dormancy. Does not spread rapidly, but a few plants are effective.

SIZE
9 – 12" tall
12" spread

SOIL
Well drained,
humus rich

PROPAGATION
Divisions of rhizomes after foliage has died

SUN
Partial shade south of Zone 5
Zones (3) 4–7

Chionodoxa forbesii

· Glory-of-the-snow
· Asparagaceae

ORIGIN
Western Turkey

ABOUT
Bulb. Lavender blue, upturned flowers with white eye in early spring. Will grow in a lawn if foliage is allowed to ripen before mowing.

SIZE
4 – 6" tall
4" spread

SOIL
Well drained,
humus rich

PROPAGATION
Self-seeds readily, also forms bulblets

SUN
Sun to partial shade
Zones (3) 4–8

Cornus officinalis

· Japanese cornel dogwood
· Cornaceae

ORIGIN
Japan, Korea

ABOUT
Deciduous tree. Airy, yellow blossoms appear before leaves and when few other trees or shrubs are in bloom.

SIZE
20 – 25' tall
35' spread

SOIL
Well drained,
humus rich

PROPAGATION
Softwood cuttings, difficult

SUN
Sun to partial shade
Zones 5–8

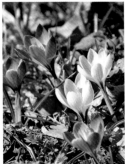 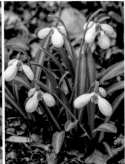 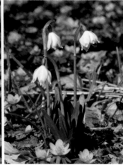

Crocus

- Dutch hybrids
- Common garden crocus
- Iridaceae

ORIGIN
Variable parentage

ABOUT
Corm. Yellow, white, or purple chalice-shape flowers in early spring. Few pests or diseases, but corms are occasionally eaten by mice or squirrels.

SIZE
5″ tall
6″ spread

SOIL
Well drained, humus rich

PROPAGATION
Separation of cormels in fall

SUN
Sun to light shade
Zones 4–8

Crocus tommasinianus

- Tommies
- Iridaceae

ORIGIN
Former Yugoslavia

ABOUT
Corm. Lavender and silver chalice-shape blossoms in earliest spring. Orange stigmas. If grown in a lawn, delay mowing or raise mower to 3″ until foliage ripens. Less attractive to squirrels.

SIZE
4–6″ tall
6″ spread

SOIL
Well drained, humus rich

PROPAGATION
Separation of cormels, seed

SUN
Sun to partial shade
Zones (3) 4–8 (9)

Eranthis hyemalis

- Winter aconite
- Ranunculaceae

ORIGIN
Western Europe

ABOUT
Herbaceous perennial. Yellow buttercup-like flowers surrounded by green bract that forms a "ruff." Plant tubers in early fall after soaking briefly in water.

SIZE
4–6″ tall
4″ spread

SOIL
Fertile, well drained

PROPAGATION
Self-seeding or division of tubers

SUN
Sun to partial shade
Zones 3–7

Galanthus

- Snowdrop
- Amaryllidaceae

ORIGIN
Europe and Middle East

ABOUT
Bulb. Strap-like foliage, white flowers in late winter.

SOIL
Well drained, humus rich

PROPAGATION
Offsets, seeds

SUN
Sun to partial shade
Zones (3) 4–7

FOUND ON THE MARCH BANK ARE:

G. elwesii

- Giant snowdrop

ORIGIN
Asia Minor

SIZE
9–12″ tall, 6″ spread

G. nivalis

- Common snowdrop

ORIGIN
Northern Europe

SIZE
6–9″ tall, 12″ spread

Leucojum vernum

- Spring snowflake
- Amaryllidaceae

ORIGIN
Central Europe

ABOUT
Bulb. White, nodding flowers that look like ballerina skirts, each segment tipped with green.

SIZE
10–12″ tall
10″ spread

SOIL
Adaptable, moisture tolerant

PROPAGATION
Offsets, seeds

SUN
Sun to partial shade
Zones 3–9

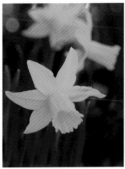

Narcissus

· Daffodil
· Amaryllidaceae

ORIGIN
Europe and
North Africa

ABOUT
Bulb. Yellow, trumpet-type daffodils. Very early blooming.

SIZE
5 – 7″ tall
4″ spread

SOIL
Well drained

PROPAGATION
Seeds or offsets

SUN
Zones 4–9

NOTE
N. asturiensis,
N. minor, N. nanus
and others listed in
catalogues as early,
yellow, and 5 – 10″
in height would do
well in a planting of
Chionodoxa forbesii
and/or *Scilla siberica.*

Sanguinaria canadensis

· Bloodroot
· Papaveraceae

ORIGIN
Eastern North
America

ABOUT
Herbaceous perennial.
Flowers with pure
white petals and
yellow stamens emerge
from a distinctive
rolled, lobed leaf. Red
sap, rhizomes, and
stems. Foliage dies
down by late summer.

SIZE
3 – 6″ tall
8″ spread

SOIL
Moist, well drained,
neutral to slightly acid

PROPAGATION
Self-sowing or division
after flowering

SUN
Partial shade to shade
Zones 3–8 (9)

CULTIVAR
'Multiplex,'
a double form

Scilla siberica

· Siberian squill
· Asparagaceae

ORIGIN
Siberia

ABOUT
Bulb. Royal blue,
nodding flowers.
Strap-like foliage.

SIZE
3 – 6″ tall
4″ spread

SOIL
Well drained

PROPAGATION
Self-seeds,
separation of offsets

SUN
Sun or partial shade
Zones 2–7

CULTIVAR/
RELATED SPECIES:
'Spring Beauty' grows
at Winterthur, along
with *S. bifolia,* two-leaved squill

Johnny Appleseeding

Curator Carol Long practices what she calls Johnny Appleseeding on the March Bank. In April, she watches for the developing seed heads of spring bulbs she wants to increase and, as they ripen, distributes the seeds where she wants them to grow. Later in the year, she helps wildflowers in the same way. This practice is a refinement of the theories of William Robinson, who advocated allowing plants to spread as they would naturally.

EAST TERRACE

Late January to April

The East Terrace can be used as a model for bringing winter interest to a smaller, more formal area. This space is defined by the house, low stone walls, balustrades, and a loggia. It is open to the winter sun but sheltered from the wind. Here, plants with early and overlapping bloom times offer combinations of white, yellow, lavender, and blue flowers from January to March. Their fragrance entices you to wander out to the garden on milder days.

Starting the show on the terrace are three small plants that work well on the large scale of the March Bank and in this more intimate space: white snowdrops (*Galanthus* species), yellow adonis *(Adonis amurensis)*, and lavender Tommies *(Crocus tommasinianus)*. Among the earliest winter-into-spring flowers, they grow together in a planting bed, sheltered by masonry and under shrubs that also flower in winter. One of the shrubs is Chinese

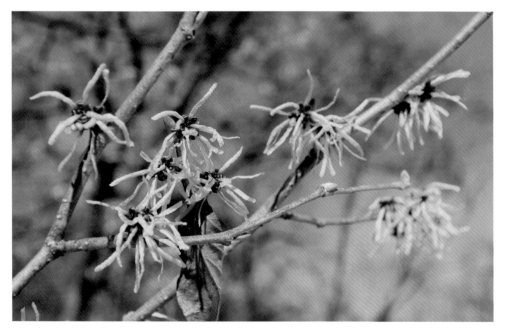

Chinese witch hazel.

Tommies in February on the East Terrace.

witch hazel *(Hamamelis mollis)*, which every February produces yellow flowers with strap-like petals that look like bits of fringe. Prized for its early flowering time, it is also valued for its handsome habit and brilliant yellow fall foliage. The cultivar growing on the terrace is Princeton Gold.

Also flowering here in winter is fragrant honeysuckle *(Lonicera fragrantissima)*, a shrub with creamy blossoms that flower over a long period. Both witch hazel and honeysuckle offer fragrance: the witch hazel is subtle and pleasant; the honeysuckle, living up to the promise of *fragrantissima*, is mesmerizing. Trailing branches of winter jasmine *(Jasminum nudiflorum)* hang from a nearby balustrade. This shrub produces yellow, open-face, tubular blossoms on warm days and continues to flower into spring. In the home garden, you might allow winter jasmine to ramble over a retaining wall or let it grow into the branches of a dark evergreen (since the flowers appear before the foliage). Reinforcing the yellow theme, a cornelian cherry dogwood tree *(Cornus mas)* sends out airy blossoms over all in March.

Exemplifying another Robinsonian concept, two familiar bulbs add color to the winter lawn on the terrace. The earliest to appear are Tommies, which have formed a flourishing colony.

The Winterthur Garden Guide: Color for Every Season

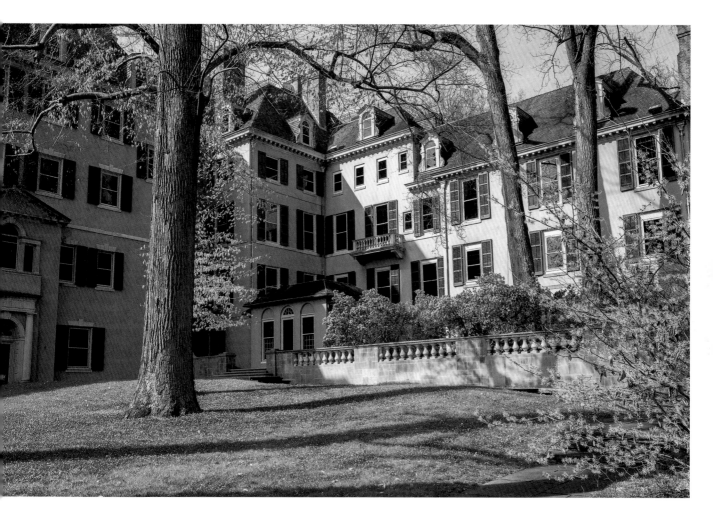

Lavender and silvery petals blend to produce drifts of a most beautiful hue. When they have faded, glory-of-the-snow *(Chionodoxa forbesii)* forms sheets of bright lavender blue flowers that make a striking display when combined with the yellows, creams, and spring greens nearby.

Broadleaf evergreens also play a role here, adding solidity and year-round green. Two with late winter flowers are Japanese pieris *(Pieris japonica)* and sweet-box *(Sarcococca hookeriana* var. *humilis)*. Japanese pieris is a sizable shrub with glossy foliage and hanging clusters of white flowers that open in late March. Sweet-box, a much smaller plant, also has lustrous green leaves and tiny, sweet-smelling, cream blossoms.

Glory-of-the-snow in the lawn, Pieris japonica (background), and Princeton Gold witch hazel flowering on the East Terrace.

Witch Hazel

Witch hazels (*Hamamelis* species and cultivars) deserve special mention as candidates for a winter garden. They are so reliable as February-blooming plants that many are used in Winterthur's public reception areas to supply color during the final stretch of winter. Several Pallida Chinese witch hazels (*H. mollis* 'Pallida') are prominent at the Visitor Center and near the Galleries. The flowers—soft sulfur yellow, fragrant and profuse—last for several weeks. As its name suggests, Pallida is a lighter yellow than the species. Du Pont had selected a Chinese form with deeper yellow flowers to use on the East Terrace to match the golden flowers of adonis. Princeton Gold was used to match that golden color when the original plant died.

Crosses between the Japanese (*H. japonica*) and the Chinese witch hazels created more February flower colors from which to choose. These hybrid witch hazels (*H.* x *intermedia*) offer blossoms ranging from yellow to copper and red tones, depending on the cultivar. They also provide orange to red fall coloration, and all display hybrid vigor. Angelly is considered one of the best of the yellow forms and has performed well at the Galleries.

If you would like a native alternative, then consider the Vernal witch hazel (*H. vernalis*). It grows 6- to 10-feet tall and starts to flower here in January, sometimes as early as December, following its autumn coloring. The flowers range from yellow to red and mixtures thereof and persist three to four weeks. This hardy witch hazel will tolerate damp situations. 🌱

Hamamelis vernalis with Hamamelis mollis hybrids in the background.

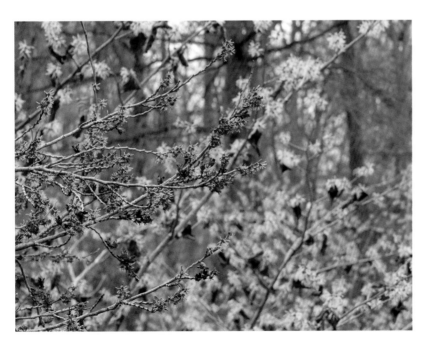

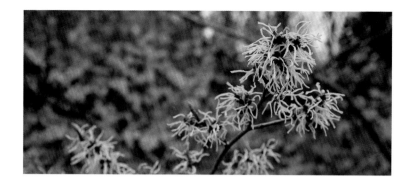

In Your Garden

Every garden can be a winter garden, offering early glimpses of color to be enjoyed. A south-facing retaining wall or a stone outcropping can provide an ideal place to coax even earlier flowers from the hardy bulbs mentioned here. A host of snowdrop cultivars are available that flower early in slightly different nuances. Shrubs such as pieris and sweet-box can provide a framework for your garden throughout the year while adding winter whites and fragrance. Witch hazels also provide structure, a range of winter color, and fall foliage. Other plants that H. F. du Pont used from time to time on the terrace were Christmas rose (*Helleborus niger*) and crocus species *C. chrysanthus* and *C. imperati*. Today we have even more options available with hellebores and crocus to color our gardens in winter.

Hamamelis

· Witch hazel

· Hamamelidaceae

ABOUT
Deciduous shrub; vigorous, dependable. Fringe-like blossoms in late fall, winter. Excellent fall foliage. Prune after flowering.

PROPAGATION
Softwood cuttings

These 2 species and a hybrid offer a choice of color, bloom time, size & hardiness:

H. x intermedia

· Hybrid witch hazel
· *H. japonica* x *H. mollis*

ORIGIN
Parents from Asia

ABOUT
Innumerable cultivars, yellow to copper to red flowers in February, before leaves. Fall foliage in similar hues.

SIZE
15 – 20′ tall
Equal spread

SOIL
Moist, well drained, acid

SUN
Sun to partial shade
Zones 5–8

H. mollis

· Chinese witch hazel

ORIGIN
China

ABOUT
Yellow flowers in February last for several weeks. Cultivars include *H. mollis* 'Pallida' – light yellow flowers and *H. mollis* 'Princeton Gold' – golden flowers.

SIZE
10 – 15′ tall
Equal spread

SOIL
Moist, well drained, acid

SUN
Sun to partial shade
Zones 5–8

H. vernalis

· Vernal witch hazel

ORIGIN
Central N. America

ABOUT
Flowers variable (yellow to red) and appear in January, sometimes in December. Cultivars available.

SIZE
6 – 10′ tall
8 – 12′ spread

SOIL
Moist, pH adaptable

SUN
Sun to partial shade
Zones 4–8

 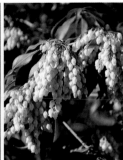 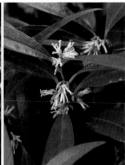 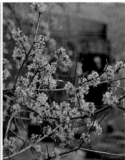 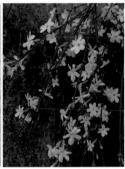

Lonicera fragrantissima

· Fragrant honeysuckle
· Caprifoliaceae

ORIGIN
China

ABOUT
Deciduous shrub.
Creamy white,
fragrant flowers and
leaves in earliest
spring. Prune after
flowering.

SIZE
6′ tall
10′ spread

SOIL
Adaptable, but
well drained

PROPAGATION
Cuttings in June

SUN
Sun to partial shade
Zones 4–8

Pieris japonica

· Japanese pieris
· Ericaceae

ORIGIN
Japan, China

ABOUT
Broadleaf evergreen
shrub. Hanging
clusters of white,
urn-shape flowers
in early spring.
Handsome leathery
leaves appear as
whorls. Prune after
flowering.

SIZE
4 – 12′ tall
3 – 8′ spread

SOIL
Well drained, acid,
high organic

PROPAGATION
Cuttings in fall
Many cultivars

SUN
Sun to partial shade
Zones (4) 5–7

Sarcococca hookeriana var. *humilis*

· Sweet-box
· Buxaceae

ORIGIN
China

ABOUT
Small evergreen
shrub. Handsome
foliage; small, creamy,
fragrant flowers in
early spring. Problem
free. Stoloniferous;
can be used as
ground cover.

SIZE
18 – 24″ tall
24″ spread

SOIL
Moist, well drained,
acid, high organic

PROPAGATION
Cuttings in winter

SUN
Shade to partial shade
Zones (5) 6–8

Cornus mas

· Cornelian cherry
 dogwood
· Cornaceae

ORIGIN
Europe, Western Asia

ABOUT
Deciduous tree.
Ethereal flowers in
yellow clusters on
bare branches in early
spring. Pest free.

SIZE
20 – 25′ tall
20′ spread

SOIL
Neutral, well drained

PROPAGATION
Softwood cuttings
Cultivars available

SUN
Sun to partial shade
Zones 4–7 (8)

Jasminum nudiflorum

· Winter jasmine
· Oleaceae

ORIGIN
China

ABOUT
Deciduous shrub;
trailing branches.
Yellow flowers on
warm winter days,
before leaves. Prune
after flowering.

SIZE
3 – 4′ tall
(to 15′ tall,
with support)

SOIL
Adaptable

PROPAGATION
Cuttings

SUN
Sun or shade
Zones 6–10

For detailed information on these species, see "March Bank": **Adonis amurensis** (Amur Adonis); **Chionodoxa forbesii** formerly *C. luciliae* (Glory-of-the-snow); **Crocus tommasinianus** (Tommies); **Galanthus** (Snowdrop), **G. cilicicus** (Cilician snowdrop), from Turkey, is an early-blooming species that du Pont used on the terrace.

SPRING

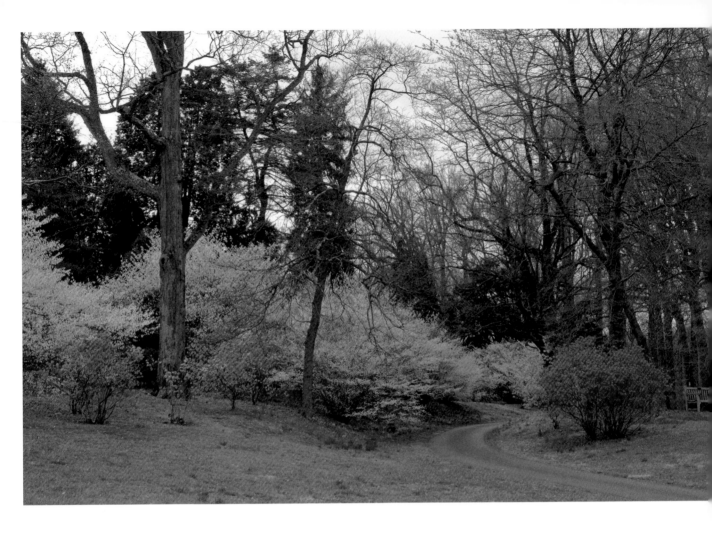

IN SPRING, EACH WEEK BRINGS NEW DELIGHTS IN THE GARDEN.
These discoveries may be the unveiling of bold sweeps of color, the layering of color
in the woodlands, the careful coordination of flowering time, or the simple beauty of
an individual flower. The concepts that Mr. du Pont used in creating his spring garden
can be followed in gardens of any size. You may choose to select these exact plants and
combinations since they are proven performers or incorporate the ideas with plants and
colors unique to your garden.

WINTERHAZEL WALK

Early April to Early May

The Winterhazel Walk exemplifies many of the ways that du Pont used color in the garden. This area offers an intriguing collection of shrubs and perennials with early April flowers in complementary colors. Forming the backbone of the walk are two shrubs: soft yellow winterhazel (*Corylopsis*) and rosy lavender Korean rhododendron (*Rhododendron mucronulatum*). H. F. du Pont first observed this combination in his garden around 1920, noting that these Asian plants flowered at the same time and that their chemistry was just right. He then built an entire walk around them, adding perennials and bulbs with similar flower colors to coordinate with the shrub layer and to enhance the woodland carpet. The cool yellow and warm lavenders of the winterhazels and Korean rhododendrons work well with the lavender blue of *Chionodoxa forbesii*, still in bloom nearby, and are set off well against the evergreens of the Pinetum.

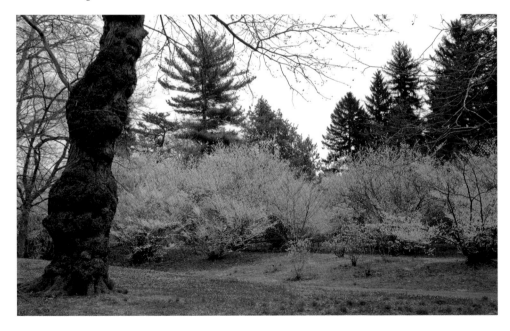

Chionodoxa adds a carpet of lavender blue.

Accompaniments

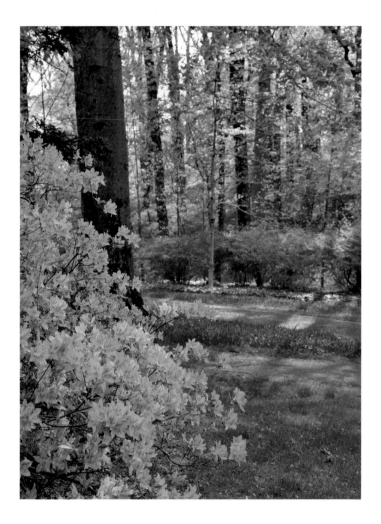

Korean azalea with soft green foliage of early spring.

Growing in smaller numbers in the Winterhazel Walk are two harmonizing shrubs, one offering early foliage, and one extending the bloom season. Cherry prinsepia (*Prinsepia sinensis*) has foliage and straw yellow flowers that appear as early as the flowers of winterhazels and Korean rhododendron. Du Pont valued it for its light green foliage. A shrub with attractive, arching branches, prinsepia is easy to grow and is pest free (although thorn bearing). Continuing the color scheme and extending the bloom season is *R. yedoense* var. *poukhanense*, commonly called Korean azalea (as distinct from Korean rhododendron), in rosy lavender. This shrub blooms in late April, after the main flowering of the Winterhazel Walk has passed.

Several low, herbaceous plants in lavender, mauve, chartreuse, and pale yellow flower in early April to echo the colors of the shrubs. The flowers of the lenten rose (*Helleborus* x *hybridus*) are the first to appear and are the predominant groundcover for the path known as the Hellebore Walk. The "blossoms" of the hellebores are actually sepals rather than petals and are available in shades of pink, mauve, yellow, chartreuse, and white.

The brightly colored sepals appear in March, sometimes as early as February, and will slowly fade but are still showy into May. A delicate addition to the ground layer is the bulb corydalis (*Corydalis solida* sbsp. *densiflora*), with dainty mauve blossoms that end in saucy little upturned spurs. A mass planting of these 8-inch plants provides a striking contrast to the coarser foliage of the hellebores. *Narcissus* 'Hunter's Moon,' an early-flowering pale yellow daffodil, further strengthens the yellow theme.

Other plants that du Pont used from time to time on Winterhazel Walk are pasque flower (*Anemone pulsatilla*), with rosy lavender flowers, and two primulas: drumstick primrose (*Primula denticulata*), with soft lavender globe-like flower heads, and abchasica primrose (*P. abchasica*), with rich cerise flowers with a yellow center. False Solomon's seal (*Smilacina racemosa*) extends the flowering season into May with ivory plumes. By this time, the lenten roses have put up splays of dark green foliage, ferns have unfurled, and the Hellebore Walk has become an attractive woodland garden. 🌱

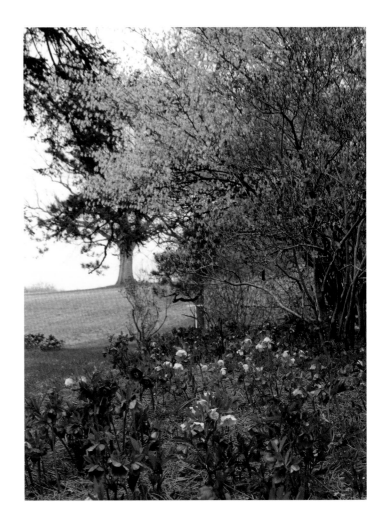

The Hellebore Walk has a long season of color with flowers opening in early spring.

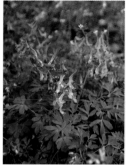
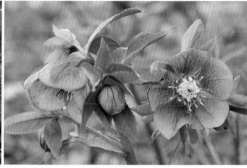

In Your Garden

Winterhazels and Korean rhododendron bring many assets to a mixed shrub border. After its early flowering, winterhazel gradually becomes straw yellow, as papery bracts remain when the petals fall. It will brighten a border for weeks in early spring and mix well with later-flowering shrubs. Gradually bringing forth leaves of golden green, it continues to add a bright note to the border and provides an excellent foil for other colors. Winterhazel and Korean rhododendron are splendid subjects for indoor forcing of early spring flowers and will develop excellent fall color as well. Hellebores also provide a bonus, with dark green, glossy foliage that persists through mild winter months. A wide range of flower colors, patterns, and forms are available to brighten the late winter and spring garden.

Corydalis solida **sbsp. *densiflora***

· Bulb corydalis
· Fumariaceae

ORIGIN
Europe, Asia

ABOUT
Herbaceous perennial; grows from a corm-like tuber. In earliest spring, 10–20 flowers appear on each upright stem. Handsome leaves, much divided.

SIZE
8" tall
Equal spread

SOIL
Evenly moist, near neutral pH

PROPAGATION
Seed, sown as soon as ripe

SUN
Partial shade
Zones 5–8

Helleborus x *hybridus*

· Lenten rose
· Ranunculaceae

ORIGIN
Eastern Europe, Turkey

ABOUT
Herbaceous perennial. Saucer-like blossoms in white, mauve, purple, some greenish, some spotted. Broad, palmate leaves. Easy to grow.

SIZE
18" tall
15" spread

SOIL
Moist, well drained (although will tolerate heavier, slightly alkaline soil)

PROPAGATION
Self-sows

SUN
Partial shade
Zones 4–8 (9)

RELATED SPECIES
H. foetidus

· Bearsfoot hellebore

ORIGIN
Europe

ABOUT
Herbaceous perennial. Chartreuse or light green cup-shape blossoms on ends of branched stems. Narrow, palmate leaves.

SIZE
18 – 24" tall
18" spread

SOIL
Moist, well drained (although will tolerate heavier, slightly alkaline soil)

SUN
Partial shade
Zones 5–7 (8)

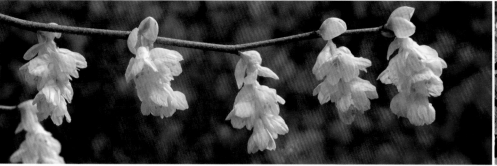
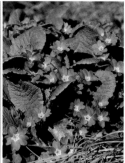

Corylopsis

· Winterhazel · Hamamelidaceae

ABOUT
Four types of winterhazel grow in this area.
All are deciduous shrubs with primrose yellow
flowers in slender, pendulous clusters in earliest
spring, before leaves. Heights and flowering
characteristics differ. Like many in the witch
hazel family, *Corylopsis* is pest free although
open flowers may be damaged by late frosts.

PROPAGATION
Softwood cuttings

Primula abchasica

· Abchasica primrose
· Primulaceae

ORIGIN
Caucasus

ABOUT
Herbaceous perennial.
Cerise petals with
yellow center.

SIZE
6″ tall
Equal spread

SOIL
Moist, well drained

PROPAGATION
Division

SUN
Partial shade
Zones 4–8

C. pauciflora

· Buttercup
 winterhazel

ORIGIN
Japan and Taiwan

ABOUT
Dainty, fragrant
flowers in clusters
of 2–3.

SIZE
4 – 6′ tall
6′ spread

SOIL
Moist, well drained

SUN
Partial shade
Zones 6–8

C. platypetala

ORIGIN
China

ABOUT
Flowers in clusters
of 8–20, each about
2″ long.

SIZE
8 – 10′ tall
10′ spread

SOIL
Moist, well
drained, acid

SUN
Sun to partial shade
Zones 6–8

C. spicata

· Spike winterhazel

ORIGIN
Japan

ABOUT
Purplish emerging
foliage; forms
clusters of 6–12.

SIZE
6 – 10′ tall
6 – 8′ spread

SOIL
Fertile, acid or neutral

SUN
Sun to partial shade
Zones 5–8

C. 'Winterthur'

· Winterthur
 winterhazel

ORIGIN
Japan and Taiwan

ABOUT
Fragrant hybrid,
thought to be a cross
between *C. spicata* and
C. pauciflora. Clusters
of 4–10 flowers.

SIZE
6′ tall
Equal spread

SOIL
Moist, well drained,
acid, humus rich

SUN
Sun to partial shade
Zones 6–8

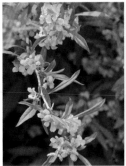
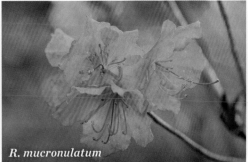

R. mucronulatum

Prinsepia sinensis

· Cherry prinsepia
· Rosaceae

ORIGIN
Manchuria

ABOUT
Deciduous shrub.
Small, pale yellow
flowers, early
foliage on arching
branches. Pest free.

SIZE
6 – 10′ tall
10′ spread

SOIL
Adaptable

PROPAGATION
Seed, softwood
cuttings

SUN
Sun
Zones 4–7

Rhododendron

· Azaleas and rhododendrons
· Ericacae

ABOUT
Two species of
Rhododendron grow on
Winterhazel Walk.

SOIL
Acid, moist,
well drained,
organically rich

R. mucronulatum

· Korean
 rhododendron

ORIGIN
China, Korea, Japan

ABOUT
Deciduous shrub;
flowers appear very
early, before leaves,
shades of lavender and
pink. Trouble free.

SIZE
4 – 8′ tall
Equal spread

CULTIVAR
'Cornell Pink'

SUN
Partial shade
Zones 4–7

R. yedoense var. *poukhanense*

· Korean azalea

ORIGIN
Korea

ABOUT
Evergreen shrub;
funnel-shape blossoms
in clusters of 2–4,
shades of lavender.

SIZE
3 – 4′ tall
6′ spread

SUN
Sun or partial shade
Zones (4) 5–7

Smilacina racemosa

· *Maianthemum
 racemosum*
· False Solomon's seal
· Asparagaceae

ORIGIN
North America

ABOUT
Herbaceous perennial,
easy to grow. Ivory
plumes on arching
stems. Alternate
broad, pointed leaves.
Red berries.

SIZE
2 – 3′ tall
4′ spread

SOIL
Moist, acid,
humus rich

PROPAGATION
Division in
spring or fall

SUN
Partial shade to shade
Zones 3–7 (8)

GREENSWARD

Early April

Flowering near the Winterhazel Walk at the same time is the Greensward, an enchanting pink wonderland that includes several shrubs and some exceptionally beautiful cherry trees. Among the trees that provide height and significance is the exquisite cherry Accolade (*Prunus* 'Accolade'). A nice size for the home garden, it is covered with soft, semi-double, white blossoms tinged with pink, which combine well with nearby shrubs that flower in shades of pink and white, including fragrant viburnums (*V. farreri*), pink and white Nanking cherries (*Prunus tomentosa*), and vibrant pink Cornell Pink rhododendron (*R. mucronulatum* 'Cornell Pink'). These plants flower at overlapping times, adding interest for several weeks.

Just across Garden Lane, two huge Sargent cherries (*Prunus sargentii*), with pink-tinged white blossoms, counterbalance this group. If you have a generous space, you may want to grow one or more of these magnificent trees. During this same time, rare rhododendrons at the edge of Azalea Woods put forth lovely pink trusses. Farges rhododendron (*R. oreodoxa* var. *fargesii*) produces an unparalleled flower spectacle in early April provided there are no late frosts.

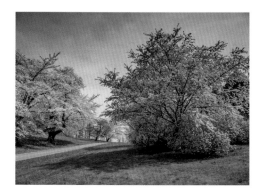

Clouds of white and pink cherry blossoms above Rhododendron mucronulatum 'Cornell Pink.'

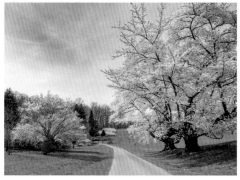

White blossoms of Prunus sargentii gradually take on a pinkish cast, harmonizing with pink and white plants of the Greensward.

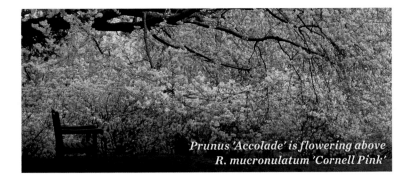

Prunus 'Accolade' is flowering above
R. mucronulatum 'Cornell Pink'

In Your Garden

Although some cherries may be short-lived and somewhat trouble prone, both Accolade and Sargent cherries have proved themselves to be dependable. Grouped with Cornell Pink rhododendron and some of the feathery pink or white shrubs described here, either cherry would make a delightful corner or island planting for a home property.

Prunus

· Cherry
· Rosaceae

ABOUT
The genus Prunus includes cherries, peaches, apricots, plums, and almonds. These two cherry trees and one shrub are deciduous and have flowers that appear before the leaves.

PROPAGATION
Softwood cuttings

SOIL
Adaptable

P. 'Accolade'

· Accolade cherry

ORIGIN
Parents from Japan

ABOUT
(hybrid of *P. sargentii* x *P. subhirtella*). Tree with semi-double, pink-blush white blossoms and deeper pink buds that hang from long pedicels in early spring.

SIZE
20 – 25' tall
25' spread

SUN
Sun to partial shade
Zones 4–7 (8)

P. sargentii

· Sargent cherry

ORIGIN
Japan

ABOUT
Handsome, huge spreading tree; clusters of single white flowers become pink. Excellent fall color.

SIZE
20 – 50' tall
Equal spread

SUN
Sun
Zones 4–7

P. tomentosa

· Nanking cherry

ORIGIN
China, Japan

ABOUT
Fragrant, spreading shrub covered with small, single white or pink flowers in early spring; red fruit.

SIZE
6 – 10' tall
8 – 15' spread

SUN
Sun to partial shade
Zones (2) 3–7

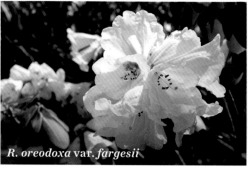

R. oreodoxa var. *fargesii*

Rhododendron

· Rhododendron
· Ericaceae

SOIL
Acid, moist, well drained, organically rich

Two early-blooming rhododendrons are described below.

For detailed information, see "Other Rhododendrons," p. 72.

R. oreodoxa var. *fargesii*

· Farges rhododendron

ORIGIN
China

ABOUT
Evergreen, large-leaf rhododendron; trusses of 7–10 pink, bell-shape blossoms. Occasionally suffers blossom damage from late frost; may need winter protection, though buds are quite hardy.

SIZE
6′ tall
Equal spread

SUN
Partial shade
Zones 6–9

R. mucronulatum 'Cornell Pink'

· Cornell Pink rhododendron

ORIGIN
Species from China, Korea, Japan

ABOUT
Deciduous shrub; selected cultivar of the species. Vibrant pink blossoms on bare branches in earliest spring.

SIZE
4 – 8′ tall
Equal spread

SUN
Partial shade
Zones 4–7

Viburnum farreri

· Fragrant viburnum
· Adoxaceae

ORIGIN
China

ABOUT
Deciduous, upright shrub; trouble free. Deep pink buds; pink flowers in small clusters appear before the leaves. Lovely scent. Prune after flowering.

SIZE
8 – 12′ tall
Equal spread

SOIL
Moist, well drained, slightly acid

PROPAGATION
Softwood cuttings

SUN
Sun to partial shade
Zones (4) 5–8

CULTIVAR
V. farreri 'Candidissima'

· Candidissima viburnum

ABOUT
White flowers.

C. S. Sargent

Charles Sprague Sargent, the first director of Arnold Arboretum in Massachusetts, was a friend of H. F. du Pont and his father, Henry Algernon. The du Ponts supported the arboretum, which in turn sent many newly discovered plants to Winterthur. The Sargent cherries, named for C. S. Sargent, arrived at Winterthur in 1918. At that time, Sargent encouraged the du Ponts' plan to create a Pinetum, which now stands as a backdrop for the Greensward and nearby areas.

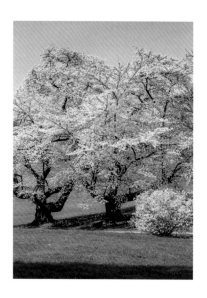

FORSYTHIAS & DAFFODILS

Early to Mid-April

Forsythias and daffodils are natural companions: both are early-flowering, cheerful plants primarily in shades of yellow. At Winterthur they often mingle as mass plantings seen from a distance.

They are easy to grow and long lasting. Mr. du Pont had a lifetime interest in daffodils, so his theories and practices in using them are of special note.

Border forsythia (Forsythia x intermedia) flowers with magnolias and daffodils at Magnolia Bend.

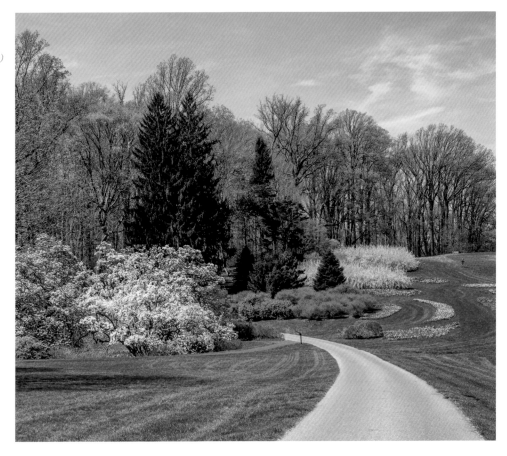

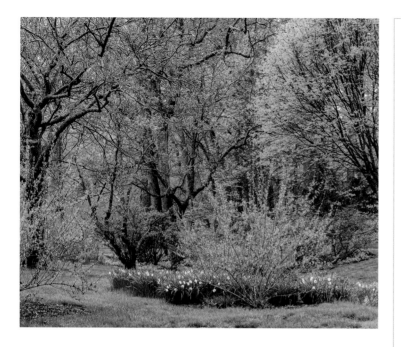

Forsythias

For plantings throughout the Winterthur garden, we have four types of forsythia that offer various hues and successive bloom. The first to appear is early forsythia (*Forsythia ovata*), flowering about two weeks ahead of the others. A cross between it and *Forsythia* 'Spring Glory' resulted in the forsythia named 'Winterthur.' Its pale yellow flowers appear slightly later, harmonize with early yellow daffodils, and complement the lavender of our native redbuds (*Cercis canadensis*). The border forsythia (*F.* x *intermedia*) provides a prolific flowering backdrop for beds of

Lavender redbuds complementing the yellow of Forsythia 'Winterthur.'

Pink Daffodils and a Maple

When daffodils with a pink-tinged trumpet became available after 1939, du Pont chose 'Mrs. R. O. Backhouse' to plant under his cut-leaf Japanese maple (*Acer palmatum* var. *dissectum*) at Magnolia Bend. Such pink- to apricot-color daffodils, readily available today, make lovely companions to plants with rust-color foliage.

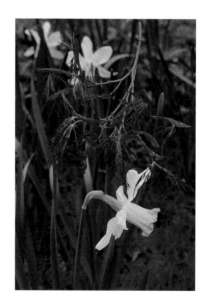

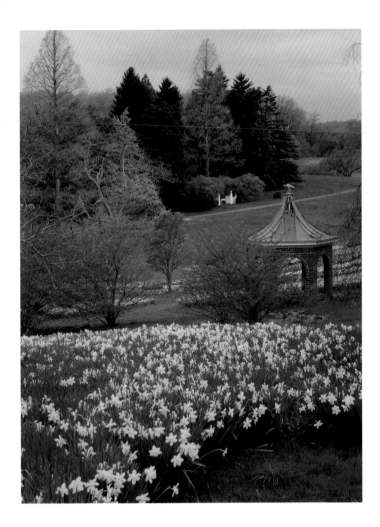

Drifts of Narcissus 'Queen of the North' above the Brick Lookout.

yellow Emperor daffodils (*Narcissus* 'Emperor'). One of its parents, green-stem forsythia (*F. viridissima*), blooms a little later. Both have gracefully arching branches. Since forsythias flower when they are leafless, the yellows show up well against dark evergreens such as pines or other conifers.

Daffodils

Du Pont's affection for daffodils (*Narcissus* species and cultivars) is apparent in April, when great drifts begin flowering throughout the estate. From long observation, du Pont developed definite ideas about how best to use daffodils; he preferred to plant cultivars in groups, aiming for a bold expanse of each variety. He also felt that daffodils flowering at different times should be kept separate so that fading blossoms would not detract from opening ones. Du Pont further advocated the separation of daffodils with blue-white petals from those with cream-white ones. Poeticus daffodils (*N. poeticus*), which have blue-white petals, are used along the stream in the March Bank and flower with Virginia bluebells (*Mertensia virginica*). At the top of Sycamore Hill, he used the cream-white, small-cup daffodil 'Queen of the North' in several beds to create an effective display.

In Your Garden

For our own gardens, forsythias and daffodils may be interspersed along a shrub border, set against a backdrop of pines, or simply allowed to flower together in different parts of the landscape. Although all forsythia are yellow, there are different shades available. Du Pont preferred the clear yellows. There are thousands of daffodil cultivars from which to choose, with different forms, substance, and flowering times. Most of those at Winterthur are considered to be historic, meaning that they were registered before 1940. They tend to have a lighter appearance in the landscape.

Acer palmatum var. *dissectum*

· Cut-leaf Japanese maple
· Sapindaceae

ORIGIN
Japan, China, Korea

ABOUT
Small tree or shrub. Reddish foliage, finely cut leaves. Slow growing.

SIZE
6–12' tall
Equal spread (cultivars vary, many available)

SOIL
Moist, well drained, acidic

PROPAGATION
Seed, cuttings

SUN
Sun to dappled shade
Zones (5) 6–8

Forsythia

· Forsythia

ABOUT
Deciduous shrub. Early yellow bloom, before leaves. Fast growing, pest free, durable. Prune after flowering by cutting old branches near plant base. Many cultivars.

· Oleaceae

SOIL
Adaptable

PROPAGATION
Softwood or hardwood cuttings

SUN
Sun

F. x *intermedia*

· Border forsythia

ORIGIN
Parents from Asia

ABOUT
Hybrid

SIZE
8–10' tall
10–12' spread

SUN
Zones 6–8

F. ovata

· Early forsythia

ORIGIN
Korea

ABOUT
Flower-bud hardy.

SIZE
4–6' tall, equal spread

SUN
Zones 4–7

F. viridissima

· Greenstem forsythia

ORIGIN
China

SIZE
6–10' tall
Equal spread

SUN
Zones 5–8

F. 'Winterthur'

· Winterthur forsythia

ABOUT
Hybrid *F. ovata* x 'Spring Glory.' Primrose yellow.

SIZE
6' tall, equal spread

SUN
Zones 4–7

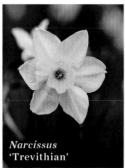
Narcissus
'Trevithian'

Narcissus
'Red Star'

Narcissus
'Laurens Koster'

Narcissus Species and Cultivars

· Daffodils
· Amaryllidaceae

ORIGIN
Originally Europe, North Africa

ABOUT
Fall-planted bulbs increase for years. Yellow, cream, white, apricot, or bicolor blossoms of various shapes appear in early spring. Upright stems, blade-like foliage. A wide variety of daffodils flourish at Winterthur, but some are no longer available commercially. Numerous hybrids, cultivars, and species listed in current catalogues will fill most present-day needs.

SOIL
Well drained, neutral to slightly acid

SUN
Sun or partial shade. *(partial shade will produce a deeper color in pink or apricot daffodils)*
Zones 3–7

N. 'Emperor'

ABOUT
Large-cup, yellow flowers.

SIZE
16 – 18" tall
12" spread

N. poeticus

ORIGIN
Europe

ABOUT
Disc-cup, white with red-rim yellow cup.

SIZE
12 – 15" tall
6" spread

N. 'Queen of the North'

ABOUT
Small-cup daffodil, white with yellow cup.

SIZE
12 – 15" tall
12" spread

N. 'Mrs. R. O. Backhouse'

ABOUT
Delicate apricot cup and white petals on strong stems.

SIZE
16 – 18" tall
12" spread

Free Forms

Most daffodils require good drainage, so planting on slopes is ideal. To attain natural-looking beds on hillsides, du Pont used fallen branches (stripped of their side shoots) to create free-form shapes. He planted bulbs within these irregular outlines, adding one or two where needed. This technique can also be used to create island beds around a group of trees or to arrange perennials in borders.

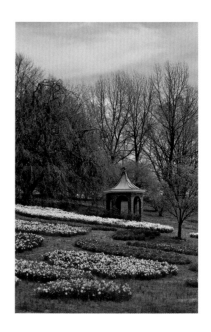

MAGNOLIA BEND

April to June

Magnolias are elegant, distinguished, and pleasing in all aspects—leaves, branching patterns, flowers, and fruit. They are also quite easy to grow. In April, Magnolia Bend is abloom with saucer magnolias (*Magnolia* x *soulangiana*), a few more than 100 years old. Their wine, pink, and ivory chalices characteristically show deeper shades at the base, lighter shades above, and a velvety ivory lining. Historic cultivars at Winterthur, all famous, are the pinkish Rustica Rubra and San Jose, rosy Alexandrina, and deep rose-purple Lennei. Their colors combine beautifully with the pinkish lavender, ball-like trusses of Conewago rhododendron (*R.* 'Conewago').

Saucer magnolias flower in the Sundial Garden as well, forming a backdrop for the lower-growing plants. Here also is the rare magnolia Wada's Memory, completely covered with 7-inch-wide white flowers in mid-April. Flowering along with these magnolias are the star magnolias (*M. stellata*) bearing fragrant white strap-like blossoms. On the museum lawn, white blossoms of the yulan magnolias (*M. denudata*) emerge chalice shape and open gradually. Late

frosts may damage blossoms on these spring-blooming magnolias but will not harm the trees themselves if they are otherwise hardy.

Elizabeth magnolia brings a yellow-flowering magnolia to the April landscape. It is a hybrid of the yulan magnolia and our native cucumbertree (*Magnolia acuminata*). Cucumbertree is a large deciduous tree with greenish yellow flowers. It is a handsome shade tree, and its flowers have provided the color to create hybrids in a wide range of yellow shades. Elizabeth has a pale yellow flower similar to other historic yellows in the Winterthur garden.

June is the month when two native magnolias begin to flower, both with a refreshing lemon scent. Sweetbay magnolia (*M. virginiana*) is a graceful tree with delicate, white blossoms and silver-lined leaves. The magnificent southern magnolia (*M. grandiflora*) unfurls ivory petals of great size and substance over a period of several weeks, forming bowl-shape blossoms with pale yellow centers.

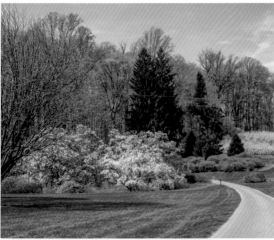

Rhododendron 'Conewago' flowers beside a collection of saucer magnolias at Magnolia Bend.

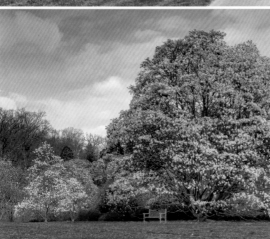

Magnolia 'Wada's Memory' with saucer and star magnolias in the Sundial Garden.

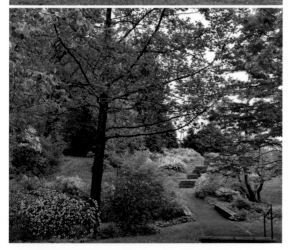

Variations on a theme: lilacs and azaleas in pink, lavender, and mauve at Magnolia Bend.

Magnolia Bend

Named for its 100-year-old saucer magnolias, Magnolia Bend is a vision of pink and white in April. The pink flowering cherries and rhododendrons in bloom at the same time in the Greensward carry these colors through the garden. In May Magnolia Bend repeats this delightful display of pink and white and adds a touch of lavender, connecting the scene to Azalea Woods. The foundation is a planting of *Rhododendron mucronatum* 'Magnifica,' which bears large, white blossoms with strawberry-speckled throats, producing an effect of palest pink. The small but prolific flowers of slender deutzia (*Deutzia gracilis*) and double Reeves spirea (*Spiraea cantoniensis* 'Lanceata') add a clear white. Close by, feathery spires of camassia (*Camassia cusickii*) flower in delicate lavender blue, while rich purple Siberian iris (*Iris siberica* 'Perry's Blue') adds punch here and there. Stone steps lead to a lower level of Magnolia Bend, where some lesser-known lilacs (*Syringa* species and a hybrid) accompany a planting of Kurume azaleas (*Rhododendron* cultivars) in lavender and mauve. ⚘

 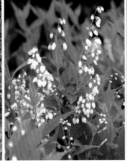 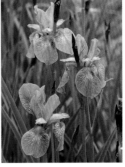

In Your Garden

Magnolia x *soulangiana* is a favorite magnolia for home landscaping. It is adaptable to many climates. It produces handsome colors in early spring and is a moderate size, growing as either a multi-stem shrub or a tree. Ease of culture and blooming when young add to its popularity. *M. stellata* and *M. denudata* are other early bloomers that are a convenient size for home grounds. Modest-size *M. virginiana* blooms later and can tolerate, but does not require, damp soils. *M. grandiflora*, where hardy, is large and magnificent. Many new hybrids of magnolias such as 'Elizabeth' are now available. They expand the color palette or flower later in spring, thus avoiding the damage and disappointment of a late frost.

Camassia cusickii

· Cusick camas
· Asparagaceae

ORIGIN
Oregon

ABOUT
Bulb. Racemes of pale lavender blue flowers arise from a basal cluster of blade-like leaves.

SIZE
2 – 3′ tall
2′ spread

SOIL
Moist in spring

PROPAGATION
Offsets

SUN
Sun to partial shade
Zones (3) 4–8

Deutzia gracilis

· Slender deutzia
· Hydrangeaceae

ORIGIN
Japan

ABOUT
Deciduous, low-spreading shrub. Upright clusters of white flowers in late May. Graceful, trouble free. Prune in early spring or after flowering.

SIZE
2 – 3′ tall
3 – 4′ spread

SOIL
Any good garden soil, well drained

PROPAGATION
Softwood or hardwood cuttings

SUN
Sun to light shade
Zones 4–8

Iris siberica 'Perry's Blue'

· Perry's blue siberian iris
· Iridaceae

ORIGIN
Species: Central Europe, Russia

ABOUT
Herbaceous perennial. Erect, fleur-de-lis-type flowers of rich purple. Blade-like foliage. Likes moist situation. Innumerable other cultivars.

SIZE
2 – 3′ tall
2′ spread

SOIL
Moist, good garden soil

PROPAGATION
Clumps expand; divide only as necessary

SUN
Sun to partial shade
Zones 3–9

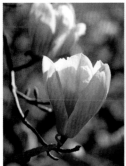 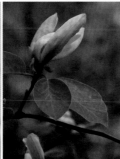 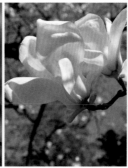 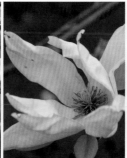

Magnolia	*M. acuminata*	*M. denudata (heptapeta)*	*M. 'Elizabeth'*	*M. grandiflora*

Magnolia

· Magnolia
· Magnoliaceae

ORIGIN
Continent

ABOUT
Blossoms of early-flowering types are sometimes damaged by frost.

SIZE
10 – 80′ tall
10 – 50′ spread

SOIL
Moist, well drained, acid. *M. virginiana* will tolerate wet soil

PROPAGATION
Cuttings of firm wood. Prune as necessary, even larger branches

SUN
Sun to partial shade
Zones 3–9 (10)

M. acuminata

· Cucumbertree
· Magnolia

ORIGIN
Eastern North America

ABOUT
Large deciduous tree. Yellowish green flowers in late April, early May but often hard to see due to height and foliage.

SIZE
40 – 80′ tall
20 – 35′ spread

SUN
Sun to partial shade
Zones 3–8

M. denudata (heptapeta)

· Yulan magnolia

ORIGIN
China

ABOUT
Deciduous tree. White, chalice-like blossoms, gradually spreading open, appear before handsome, roundish foliage. Trouble free, adaptable.

SIZE
30 – 40′ tall
25 – 30′ spread

SUN
Sun or partial shade
Zones 5–8

M. 'Elizabeth'

ORIGIN
Hybrid of *M. acuminata* and *denudata*

ABOUT
Deciduous tree. Pale yellow, 6″ cup-shape flowers in mid-April.

SIZE
20 – 35′ tall
12 – 20′ spread

SUN
Sun to partial shade
Zones 5–8

M. grandiflora

· Southern magnolia

ORIGIN
Southeastern U.S.

ABOUT
One of the region's most beautiful trees. Evergreen, glossy, leathery leaves often backed with brown indumentum (felt). Ivory, bowl-shape flowers in summer; lemon fragrance. Sometimes espaliered and kept smaller. In colder climates, avoid winter sun and wind through careful siting. Many cultivars, some with improved hardiness, smaller size.

SIZE
60 – 80′ tall
30 – 50′ spread

SUN
Sun or partial shade
Zones (6) 7–9 (10)

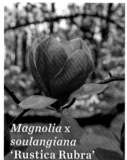

Magnolia x
soulangiana
'Rustica Rubra'

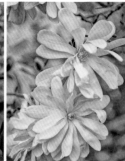

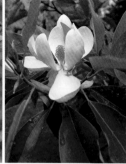

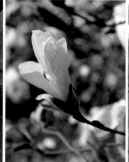

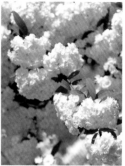

M. x *soulangiana*

· Saucer magnolia

ORIGIN
Parents: China

ABOUT
Small tree or shrub.
Chalice-shape
blossoms in wine,
pink, and white appear
in early spring, before
leaves. Flowering
begins at an early
age. Many cultivars.

SIZE
20 – 30' tall
Equal spread

SUN
Sun
Zones 4–9

M. stellata

· Star magnolia

ORIGIN
Japan

ABOUT
Deciduous tree or
shrub. Blossoms are
white with many
strap-like tepals
(petals); fragrant.
Blooms early, before
the leaves. Many
cultivars, some
pink. 'Waterlily,'
slightly larger flower
with more tepals.
Adaptable.

SIZE
15 – 20' tall
10 – 15' spread

SUN
Sun
Zones 4–8 (9)

M. virginiana

· Sweetbay magnolia

ORIGIN
Eastern U.S.

ABOUT
Tree or shrub;
deciduous in the
north, semi-evergreen
to evergreen in the
south. White, fragrant,
cup-shape blossoms
appear sporadically for
several weeks in early
summer. Attractive,
light-green foliage
with silver lining.
Easy, adaptable.
Many cultivars.

SIZE
10 – 20' tall
(to 60' in the south)
Equal spread

SUN
Sun or shade
Zones 5–9

M. 'Wada's Memory'

· Wada's Memory
 magnolia

ORIGIN
Parents: Japan

ABOUT
Large, egg-shape tree
covered with white
blossoms in April,
before the foliage.

SIZE
30 – 40' tall
20 – 30' spread

SUN
Sun
Zones 4–8

Spiraea cantoniensis 'Lanceata'

· Double reeves spirea
· Rosaceae

ORIGIN
China, Japan

ABOUT
Deciduous or semi-
evergreen shrub.
Snowy white, double
flowers are sterile.

SIZE
4 – 6' tall
Equal spread

SOIL
Moist, well drained

PROPAGATION
Cuttings

SUN
Sun to partial shade
Zones (4) 5–9

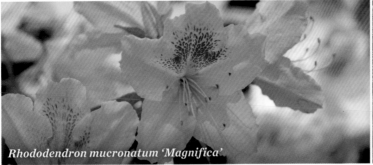

Rhododendron mucronatum 'Magnifica'

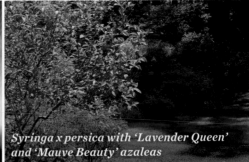

*Syringa x persica with 'Lavender Queen'
and 'Mauve Beauty' azaleas*

Rhododendron

· Azalea and
 Rhododendron
· Ericaceae

ABOUT
Three evergreen
azaleas and one
semi-evergreen
rhododendron grow
in this area.

SOIL
Moist, well drained,
acid, high organic

SUN
Sun to partial shade

*For detailed
information, see "Other
Rhododendrons," p. 69.*

R. 'Mauve Beauty'

· Mauve beauty
 Kurume azalea
ORIGIN
Parents from Asia
ABOUT
Mauve flowers
in mid-spring.
SIZE
4' tall, equal spread
SUN
Zones 6–8 (9)

R. mucronatum 'Magnifica'

· Magnifica azalea
ORIGIN
Garden origin
ABOUT
Large, white flowers
with strawberry-
speckled throat
in mid-spring.
SIZE
6' tall
6–8' spread
SUN
Zones 6–9

R. 'Lavender Queen'

· Lavender queen
 Kurume azalea
ORIGIN
Parents from Asia
ABOUT
Pinkish lavender
flowers in mid-spring.
SIZE
4' tall, equal spread
SUN
Zones 6–8 (9)

R. 'Conewago'

· R. carolinianum x
 mucronulatum
· Conewago
 rhododendron
ORIGIN
Parents from North
Carolina and Japan
ABOUT
Semi-evergreen shrub
with pinkish lavender,
ball-shape trusses
early in spring.
SIZE
4–6' tall, 3–5' spread
SUN
Zones (4) 5–8

Syringa

· Lilac
· Oleaceae

ABOUT
These deciduous lilacs
flower at the same time
as Syringa vulgaris
and cultivars but are
more modestly sized
and offer variations in
textures and habits.
Delicately fragrant.
Prune after flowering
by cutting old canes
close to ground.

SOIL
Neutral, pH adaptable,
well drained

PROPAGATION
Softwood cuttings

S. meyeri

· Meyer lilac
ORIGIN
China
ABOUT
Rounded shrub,
lavender flowers.
Excellent bloomer.
Mildew resistant.
SIZE
4–8' tall, 6–12' spread
SUN
Sun, Zones 3–7

S. laciniata

· Cut-leaf lilac
ORIGIN
China
ABOUT
Bushy shrub, deeply
lobed leaves, lavender
flowers. Feathery
texture. Fragrant.
Tolerates heat,
mildew resistant.
SIZE
6–8' tall, 9' spread
SUN
Sun, will bloom
in some shade
Zones 4–8

S. x persica

· Persian lilac
ORIGIN
Parents from
Iran and Asia
ABOUT
Arching branches,
pale lavender flowers
borne in profusion.
SIZE
4–8' tall, 5–10' spread
SUN
Sun, Zones 3–7

QUINCE WALK

April

Under the shelter of the great evergreens of the Pinetum, du Pont planted a large collection of quince that now forms Quince Walk. Pathways are lined with various cultivars that flower in warm tones and create a medley of color. Flowering quince (*Chaenomeles* species, hybrids, and cultivars) produces blooms in early spring on plants that display a distinctive branching pattern. The cup-shape blossoms open in colors from white through pinks and corals to oranges and reds, each blossom centered with bright yellow stamens. Featured prominently is the pink-and-white Appleblossom quince (*C. speciosa* 'Appleblossom'), among many others, including the almost lacquer red Rowallane (*C.* x *superba* 'Rowallane'). At the entrance to the walk, du Pont planted two Chinese snowball viburnums (*Viburnum*

Quince in a variety of colors with a backdrop of magnolias and lilacs.

Quince and Chinese snowball viburnums along Quince Walk.

macrocephalum), with huge, apple-green budded heads that appear just as the quince flowers. When the blossoms are fully open and white, the viburnums stand like beacons guiding us into the deep green of the Pinetum.

Also enhancing the quince planting is garland spirea (*Spiraea* x *arguta*), which forms delicate, gracefully arching white sprays. These line a path to the white Latimeria Gates, where a pearl bush (*Exochorda giraldii* var. *wilsonii*) blooms. The arching branches end in long clusters of pure white, ruffled blossoms, a bit like single roses laced together. The buds resemble strings of pearls and add immeasurably to the great appeal of this shrub. ❧

A Perfect Pair

The white Latimeria Gates were among several garden structures that H. F. du Pont purchased from the Latimer estate in Wilmington, Delaware, in the 1920s. Landscape architect Marian Coffin placed them in the garden. In 1929 du Pont added the pearl bushes (*Exochorda giraldii* var. *wilsonii*). They soften the hard edge of the gates and echo their color in spring.

In Your Garden

This area presents an adaptable group of plants, including shrubs that flower in luscious colors, white frothiness, or rose-like blossoms. All are happy in either sun or partial shade and are attractive for arrangements as well. A small version of the pearl bush, *Exochorda* x *macrantha* 'The Bride,' is a handsome, sprawling shrub, useful for the home garden. If you have room for larger plants, *Viburnum macrocephalum*, with its apple-green flower heads that later turn white, makes a stunning addition.

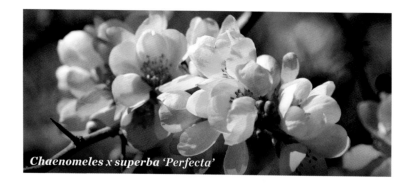

Chaenomeles x *superba* 'Perfecta'

Chaenomeles

Species, Hybrids, and Cultivars

· Flowering quince · Rosaceae

ABOUT
Deciduous shrub. Blooms in early spring, with leaves. Yellow-green fruit appears later. Hybridize freely; innumerable hybrids and cultivars available. Prune after flowering.

SOIL	PROPAGATION	SUN
Well drained, slightly acid	Softwood and hardwood cuttings	Sun to partial shade

Most quince species and hybrids have colors that blend well with others. These include:

C. japonica

ORIGIN
Japan

ABOUT
Orange-red to red blossoms.

SIZE
3' tall
Equal spread

SUN
Zones 4–8

C. speciosa

ORIGIN
China

ABOUT
Red, orange, white, or pink blossoms.

SIZE
6 – 10' tall
Equal spread

SUN
Zones 4–8 (9)

C. x superba

· *C. japonica* x *C. speciosa*

ABOUT
White, pink, orange, or red blossoms

SIZE
4 – 5' tall
Equal spread

SUN
Zones 5–8

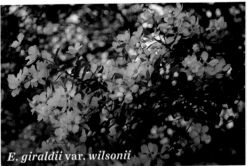

E. giraldii var. *wilsonii*

Exochorda

· Pearl bush
· Rosaceae

ABOUT
Two exochordas are grouped here. Deciduous. White, rose-type blossoms in linear clusters, pearl-like buds. Trouble free, durable. Prune after flowering.

SOIL
Tolerates a wide pH range but likes acid, well drained

PROPAGATION
Softwood cuttings

SUN
Sun to partial shade

E. giraldii var. wilsonii

· Pearl bush

ORIGIN
China

ABOUT
Tall, vase-shape shrub with arching branches.

SIZE
10 – 15′ tall
Equal spread

SUN
Zones (5) 6–7 (8)

E. x macrantha 'The Bride'

· The Bride
· Pearl bush

ORIGIN
Parents from Turkistan and China

ABOUT
Low, sprawling shrub, exquisite in its profuse bloom.

SIZE
3 – 4′ tall
4 – 6′ spread

SUN
Zones 5–8

Spiraea x arguta

· Garland spirea
· Rosaceae

ORIGIN
Parents: Europe and Asia

ABOUT
Deciduous shrub. Arching branches covered with delicate white blossoms in early spring, before leaves. Adaptable, trouble free. Similar to *S. thunbergii*. Prune after flowering by cutting largest canes near ground.

SIZE
3 – 6′ tall
Equal spread

SOIL
Any good garden soil

PROPAGATION
Softwood and hardwood cuttings

SUN
Sun to partial shade
Zones 4–8

Viburnum macrocephalum

· Chinese snowball viburnum
· Adoxaceae

ORIGIN
China

ABOUT
Large-scale shrub, deciduous to semi-evergreen, spectacular in bloom. Apple-green buds become white, 3–8″ snowballs about a month later. Prune after flowering.

SIZE
10 – 20′ tall
Equal spread

SOIL
Moist, well drained, slightly acid

PROPAGATION
Cuttings in early summer

SUN
Sun to partial shade
Zones 6–9

SUNDIAL GARDEN

April to Early May

How is it possible to create a planting plan for a squared-off area that lacks trees, slopes, or stone outcroppings? Such was the problem H. F. du Pont faced when he decided to transform the site of his tennis and croquet courts into an April garden. Homeowners often confront similar situations and may find inspiration in the charming arrangement known as the Sundial Garden.

The area is an interplay of formality and informality; beds arranged in geometric patterns create a sense of enclosure and symmetry while any rigidity of line is softened by the profusion of bloom. Plants of more upright shapes and deeper tones punctuate billowing fountains of whites, pinks, and lavenders. Large flowering quince (*Chaenomeles* cultivars), primarily salmon-and-white Appleblossom,

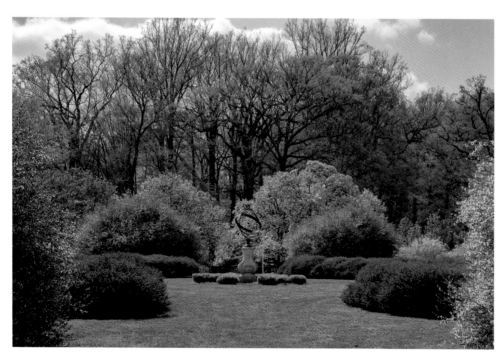

The profusion of bloom in the Sundial Garden delights us, while its symmetry and repetition appeal to our sense of order.

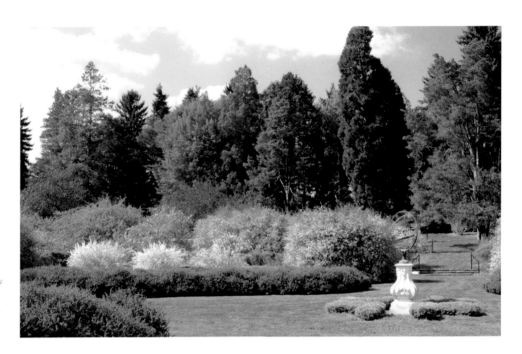

anchor the beds around a central armillary sundial. White spirea (*S.* x *arguta* and *S. prunifolia*) and pink flowering almond (*Prunus glandulosa*) make early appearances, as do stately magnolia trees (*M. stellata*, *M.* x *soulangiana*, and *M.* 'Wada's Memory') around the periphery. Several delicate Hally Jolivette cherry trees (*Prunus* 'Hally Jolivette') flower in misty pink, resembling confetti caught in the air. Crabapples (*Malus* cultivars) and Carolina silver bells (*Halesia carolina*) add height and color, while azaleas, viburnums, fothergillas, pearl bushes, and lilacs add to the crescendo of bloom that evokes the image of a room made of flowers.

Du Pont introduced the deep purplish-rose crabapple known as Henrietta Crosby (*Malus* 'Henrietta Crosby'), which adds zest to the scene. Lilacs bloom in their characteristic shades— lavender, pink lavender, lavender blue, white, and reddish purple, this last color sharpening and accenting the pastels. *Rhododendron mucronatum* 'Amethystinum' subtly echoes the lavender shades.

Green-foliage plants play a major role here in creating the structure

for this garden. An evergreen hedge of English boxwood historically surrounded the Sundial Garden. It suffered in the challenging conditions of a former tennis court and is destined to be replaced with a hybrid boxwood, *Buxus* x 'Glencoe,' trademark name, Chicagoland Green. We selected it for its cold hardiness, winter color, size, and oval shape. *Buxus sinica* var. *insularis* 'Nana' is a dwarf boxwood that anchors the base of the sundial at the center of the garden. Other evergreens such as Japanese holly (*Ilex crenata* 'Green Lustre') continue the framework for the lower courtyard.

Complements

When the Sundial Garden is in full flower, harmonizing colors surround the garden area. A mass of bright cerise *Rhododendron* 'Hinode Giri' appears nearby, and a hillside of native redbud trees (*Cercis canadensis*) provides a pink lavender mist. Soulmate to the redbuds, the azalea *R.* 'Viola' flowers in matching color and adds fullness.

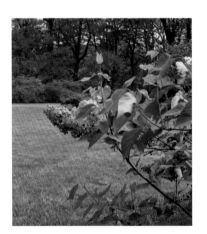

Flowering quince connects Quince Walk with the Sundial Garden.

Sundial Garden

In Your Garden

The plants in the Sundial Garden are good choices for sunny locations. They provide inspired combinations and, when used together, color for most of April into early May. The taller flowering shrubs, such as lilacs and viburnums, give not only color but also structure and screening potential to a shrub border. Crabapples, silver bells, and many of the magnolias here are a comfortable size for the home landscape. Fothergilla and bridalwreath spirea contribute spring flowers and beautiful autumn foliage color as well. There are many forms and sizes of boxwoods and evergreen hollies available to create your garden room in either sun or shade.

Buxus

· Boxwood
· Buxaceae

ORIGIN
Species: Southern Europe, Northern Africa, Western Asia, Korea

ABOUT
Evergreen shrubs, many cultivars available in a variety of sizes and forms to provide structure and year-round interest. Select ones with resistance to boxwood blight, boxwood leafminer.

SOIL
Moist, well drained

SUN
Sun to partial shade

Buxus x 'Glencoe' Chicagoland Green

ABOUT
A cold-hardy boxwood that retains good winter color.

SIZE
3 – 4' tall
Equal spread

SUN
Zone 5–8

Buxus sinica var. *insularis* 'Nana'

ABOUT
Low but fast growing, tolerance to boxwood blight.

SIZE
2' tall
3' spread

SUN
Zones 6–8

Cercis canadensis

· Eastern redbud
· Fabaceae

ORIGIN
Eastern North America

ABOUT
Graceful tree. Airy, pinkish lavender flowers appear before leaves. Good size for the home garden. Many cultivars. Prune after flowering.

SIZE
20 – 30' tall
25 – 35' spread

SOIL
Many types, well drained

PROPAGATION
Softwood cuttings

SUN
Sun to light shade
Zones (3) 4–9

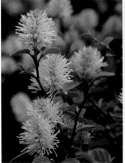
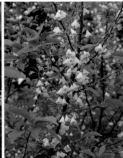
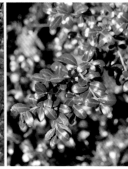
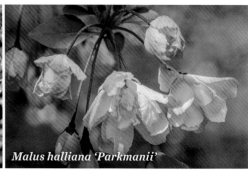

Malus halliana 'Parkmanii'

Fothergilla major

· Large fothergilla
· Hamamelidaceae

ORIGIN
Southeastern U.S.

ABOUT
Deciduous shrub. Trouble-free, white, bottlebrush-type (stamens and no petals) flowers in spring, about the same time as leaves. Handsome summer foliage, outstanding fall coloration, good habit.

SIZE
6 – 10′ tall
6 – 8′ spread

SOIL
Moist, well drained, acid

PROPAGATION
Softwood cuttings

SUN
Sun to partial shade
Zones 4–8

Halesia carolina (tetraptera)

· Carolina silver bell
· Styracaceae

ORIGIN
Southeastern U.S.

ABOUT
Deciduous tree. White, bell-shape flowers in mid-spring, before or with leaves. Pest free. Prune after flowering.

SIZE
30 – 40′ tall
20 – 35′ spread

SOIL
Moist, well drained, acid

PROPAGATION
Softwood cuttings

SUN
Sun to partial shade
Zones 4–8 (9)

Ilex crenata 'Green Lustre'

· Japanese holly
· Aquifoliaceae

ORIGIN
Species from China, Japan, Korea

ABOUT
Evergreen rounded shrub. Small, leathery, green leaves. Many other cultivars.

SIZE
3 – 4′ tall
6 – 8′ spread

SOIL
Moist, well drained and slightly acid

PROPAGATION
Softwood cuttings

SUN
Sun or shade
Zones 5–7

Malus Cultivars

· Crabapple cultivars
· Rosaceae

ORIGIN
Species: North America, Europe, Asia

ABOUT
Deciduous trees. Innumerable cultivars; species hybridize freely. Flowers range from white to pink to purple-rose; bloom with leaves in mid-spring. All have interesting fruit in red, yellow, or green shades. (Apples, with larger fruits, are also in this genus.)

SIZE
15 – 30′ tall
Equal spread

PROPAGATION
Softwood cuttings, prune soon after flowering

SOIL
Moist, well drained, acid

SUN
Sun
Zones (3) 4–8

M. 'Henrietta Crosby' and *M.* 'Adams'

ABOUT
Deep purplish-rose flowers.

M. x *atrosanguinea*

ABOUT
Purplish rose flowers.

M. halliana 'Parkmanii'

ABOUT
Rose turning pink.

*For detailed information on **Magnolia species and cultivars**, see "Magnolia Bend," p. 42.*

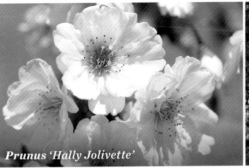
Prunus 'Hally Jolivette'

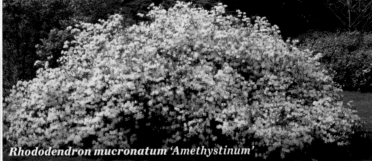
Rhododendron mucronatum 'Amethystinum'

Prunus

· Cherry
· Rosaceae

ABOUT
Genus includes cherries, peaches, apricots, plums, and almonds. Included here are a deciduous shrub and a tree.

SOIL
Any good garden soil

SUN
Sun

PROPAGATION
Softwood cuttings, prune after flowering

P. glandulosa

· Dwarf flowering almond

ORIGIN
China

ABOUT
Leafless branches covered with puffs of pink flowers in early spring. Very decorative; may be short lived.

SIZE
4 – 5' tall
Equal spread

SUN
Zones 4–8

P. 'Hally Jolivette'

· Hally Jolivette cherry

ORIGIN
Parents from Japan

ABOUT
Rounded tree or shrub. Pink buds become almost white, double flowers preceding the leaves. Flowers over a long period in early spring. Branches to the ground.

SIZE
15 – 20' tall
Equal spread

SUN
Zones 5–7

Rhododendron

· Azalea and Rhododendron
· Ericaceae

ABOUT
Early- and mid-spring azaleas and rhododendrons are found in the Sundial Garden.

SOIL
Acid, moist, well drained, high organic content

SUN
Partial shade unless otherwise noted

EARLY-SEASON CULTIVARS:

R. 'Chapmanii Wonder'

ABOUT
Evergreen shrub. Lavender pink flowers, held in compact trusses, in early spring.

SIZE
4' tall, equal spread

SUN
Sun to partial shade
Zones (5) 6–8

R. 'Conewago'

ABOUT
Semi-evergreen shrubs. Pinkish lavender, ball-shape trusses early in spring.

SIZE
4 – 6' tall, 3 – 5' spread

SUN
Sun to partial shade
Zones (4) 5–8

MIDSEASON CULTIVAR:

R. mucronatum 'Amethystinum'

· Amethystinum azalea

ABOUT
Palest lavender flowers.

SIZE
6' tall, 6 – 8' spread

SUN
Zones 6–9

NEARBY MIDSEASON CULTIVAR:

R. 'Hinode Giri'

· Hinode Giri Kurume azalea

ABOUT
A compact evergreen azalea with cerise flowers.

SIZE
4' tall, equal spread

SUN
Zones 6–8 (9)

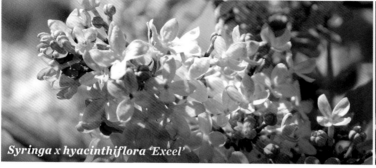
Syringa x hyacinthiflora 'Excel'

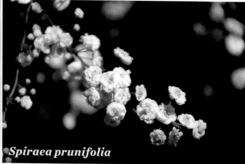
Spiraea prunifolia

Syringa

· Lilac
· Oleaceae

ORIGIN
Europe

ABOUT
Two similar lilacs
are grouped here.
Deciduous, vase-
shape shrubs;
arching branches.
Fragrant flowers form
pyramidal clusters.
Innumerable cultivars
in many colors,
most blend well.
Deadheading desirable
but not necessary.
Prune soon after
flowering by removing
largest canes near
ground level.

SIZE
8 – 15' tall
6 – 15' spread

SOIL
Neutral, pH adaptable,
well drained

PROPAGATION
Softwood cuttings

SUN
Sun
Zones 3–7 (8)

Syringa vulgaris

· Common lilac

ORIGIN
Europe

ABOUT
Noteworthy cultivars
in the Sundial Garden
are 'Mme. Charles
Souchet,' lavender
blue; 'Wedgwood
Blue,' lavender blue;
'Priscilla,' lavender
mauve; 'Katherine
Havemeyer,' pink;
'Maud Notcutt,' large,
white; 'Primrose,'
pale yellow.

S. x hyacinthiflora

· S. oblata x S. vulgaris
· Early-flowering lilac

ORIGIN
Parents from Korea
and Europe

ABOUT
Similar to S. vulgaris
but slightly larger,
more vigorous,
hardier, and
earlier blooming.
Representatives in
the Sundial Garden
include 'Assessippi,'
lavender; 'Clarke's
Giant,' large, lavender
blue. 'Excel,' single
lavender.

Spiraea

· Spirea
· Rosaceae

ABOUT
Deciduous shrubs; adaptable, trouble free.
White or pink flowers. Some types bloom
in spring, others in early summer.

SOIL
Any good garden soil

PROPAGATION
Softwood or hardwood cuttings,
prune after flowering

S. x arguta

· Garland spirea

ORIGIN
Parents from
Europe, Asia

ABOUT
Delicate white
blossoms cover
arching branches in
early spring, before
leaves. Similar to
S. thunbergii.

SIZE
3 – 6' tall
Equal spread

SUN
Sun to partial shade
Zones 4–8

S. prunifolia

· Bridalwreath spirea

ORIGIN
Asia

ABOUT
Double white,
button-like flowers
cover outstretched
branches in early
spring. Apricot-color
fall foliage.

SIZE
4 – 9' tall
6 – 8' spread

SUN
Sun
Zones 4–8

Viburnum carlesii

Viburnum

· Viburnum
· Adoxaceae

ABOUT
Easy and dependable; some of the most useful plants for the home garden. Species and cultivars (except *V. macrocephalum*) in or near the Sundial Garden have pink buds in spring that open as rounded clusters of white flowers noted for their fragrance. Many cultivars. Prune after flowering.

SOIL
Moist, well drained, slightly acid

PROPAGATION
Softwood cuttings

Success

Contemplating a new April garden in 1955, H. F. du Pont asked landscape architect Marian Coffin, a lifelong friend, to suggest a design. They had collaborated on many garden projects, and together they developed the Sundial Garden. Coffin was responsible for the graceful geometric patterns and du Pont for the lush, colorful plantings.

V. x *burkwoodii*

· Burkwood viburnum

ORIGIN
Parents from Asia

ABOUT
Large, vigorous shrub; evergreen in warm climates. 2–3″ flower clusters.

SIZE
8 – 10′ tall
5 – 7′ spread

SUN
Sun
Zones (4) 5–8

V. *carlesii*

· Koreanspice viburnum

ORIGIN
Korea

ABOUT
Deciduous shrub, 2–3″ flower clusters. Much loved for its fragrance.

SIZE
4 – 8′ tall
Equal spread

SUN
Sun to partial shade
Zones 4–7 (8)

V. x *carlcephalum*

· Fragrant viburnum

ORIGIN
Parents from Asia

ABOUT
Deciduous shrub; 5″ flower clusters.

SIZE
6 – 10′ tall
Equal spread

SUN
Sun
Zones (5) 6–8

V. x *juddii*

· Judd viburnum

ORIGIN
Parents from Asia

ABOUT
Deciduous shrub; 2–3″ flower clusters; somewhat more disease resistant than V. carlesii.

SIZE
6 – 8′ tall
Equal spread

SUN
Sun
Zones 4–8

V. *macrocephalum*

· Chinese snowball viburnum

ORIGIN
China

ABOUT
Deciduous to semi-evergreen large-scale shrub, spectacular in bloom.

SIZE
10 – 20′ tall
Equal spread

SUN
Sun to partial shade
Zones 6–9

WILDFLOWERS

April to May

Grouped here are primarily North American native wildflowers along with two non-native perennials whose charm and informality provide a similar effect in the landscape. Some are spring ephemerals, with their flowers and foliage disappearing before summer while others provide interesting leaves through to frost. Most of these appear throughout the woodlands or lawns of the Winterthur garden.

Italian Windflower

In early April on the March Bank, in Azalea Woods, and in other woodland shelters, we find delightful floral carpets of Italian windflowers (*Anemone apennina*). These daisy-like flowers in white or shades of lavender blue (with the harmonious variations found in colonies of seedlings) have yellow centers and foliage that is deeply

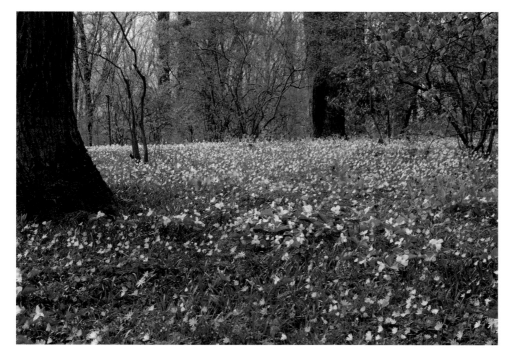

Italian windflower (Anemone apennina) thrives particularly in Azalea Woods and on the March Bank.

cut and attractive. The blossoms close in rainy weather but on sunny days produce a scene that is remarkable for its simplicity and effectiveness.

Spring Starflower

Also in early April, a mass of palest blue, star-like blossoms, no more than six inches high, appears just below the stone wall of the Pinetum. Spring starflower (*Ipheion uniflorum*) flowers here in the lawn with crabapples, quince, and viburnums. Its fragrance and delicate blue color make it especially appealing. The bulbs will go dormant, and the foliage will disappear in late spring, but new foliage emerges in fall and lasts through winter. Having escaped cultivation, this plant has naturalized in some parts of the country.

Springbeauty

Our native springbeauty (*Claytonia virginica*) brightens the Winterthur lawns through most of April. Their individual flowers are less than an inch across, but in quantity, they create a white sea reflecting the white of magnolias and daffodils. If you look closely, you will discover some with pink flowers. The strap-like leaves of this low-growing plant will emerge in early spring and disappear by late spring.

Virginia Bluebells

Certain plants appear in such great numbers and are so widespread that when in flower, their radiance permeates the entire Winterthur landscape. Among these are Virginia bluebells (*Mertensia virginica*) or Brandywine bluebells as they are sometimes called. Flowering in clusters of hanging "bells," this plant is native to the eastern United States and is ideal for partially shaded areas in the home garden. The pink buds open in shades of blue and occasionally pink or white flowers. If content, these plants will colonize an area without becoming invasive. Their foliage arrives early and disappears by summer, providing space for other shade perennials such as ferns, hostas, or hardy begonias. In warmer climates, they appreciate a moist situation.

Large-leaf Bellwort

The golden yellow flowers of the large-leaf bellwort (*Uvularia grandiflora*) brighten the woodlands of the garden in late April and early May. The bell-shape flowers dangle from the tops of their two-foot arching stems. The foliage will persist through the growing season and provides a nice textural contrast with the broad leaves of hostas or with lacy ferns.

Solomon's Seal and False Solomon's Seal

Solomon's seal (*Polygonatum biflorum*) and false Solomon's seal (*Smilacina racemosa*) are native plants that thrive in moist, shady situations. They have similar foliage and look somewhat alike before they flower. "True" Solomon's seal has small, pendulous flowers arranged in pairs at the leaf axils; false Solomon's seal has a generous plume at the end of the stem, which is more visible, more showy. Both types of inflorescence are greenish white and appear during May. The foliage is showy through fall.

Wild Blue Phlox

Wild blue phlox (*Phlox divaricata*) is true to its botanical name: *divaricata* means "spreading." Yet, its soft lavender color is so pleasing in great drifts that most gardeners will not mind this tendency. This phlox is low growing (about a foot high) and undemanding. If taking up too much room, it is easy to pull up. It likes bright shade but will tolerate a fair amount of sun. In early May at Winterthur, its pale lavender flowers color the lawns and woods.

Bright cerise of Rhododendron 'Hinode Giri' with the distinctive blue of Virginia bluebells (*Mertensia virginica*) in late April.

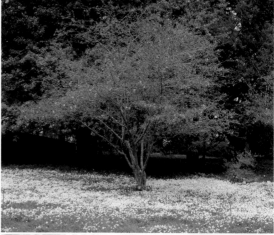

Spring starflower (*Ipheion uniflorum*) adds ground-level interest under Malus halliana 'Parkmanii.'

Phlox divaricata spreads to form drifts of soft lavender with yellow highlights from buttercups.

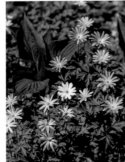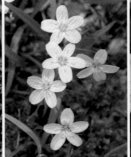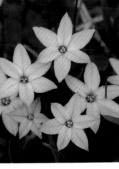

Wildflowers

In Your Garden

Any of these plants will contribute handsomely to shady or partly shady spots in a home garden, adding refreshing color to a perennial bed or under shrubs in a border. The low growers, such as Italian windflower, starflower, or springbeauty would prosper in a rockery, along a path or in the lawn. Solomon's seal and false Solomon's seal are well suited to a woodland setting and will provide fruit interest in the fall. All are easy to grow and will add a naturalistic touch to your spring garden.

Anemone apennina

· Italian windflower
· Ranunculaceae

ORIGIN
Southern Europe

ABOUT
Low herbaceous plants. White to lavender daisy-like blossoms. Handsome, deeply cut leaves die down in early summer.

SIZE
9" tall
Equal spread

SOIL
Woodsy, high organic content

PROPAGATION
Self-seeds or divide in early summer

SUN
Dappled shade
Zones 5–7

Claytonia virginica

· Springbeauty
· Montiaceae

ORIGIN
Eastern North America

ABOUT
Low-growing wildflower that naturalizes readily. White to pink flowers in April; dies back in summer.

SIZE
3 – 6" tall
6" spread

SOIL
Moist, well drained

PROPAGATION
Self-sows

SUN
Sun to partial shade
Zones 3–8

Ipheion uniflorum

· Spring starflower
· Amaryllidaceae

ORIGIN
Argentina, Uruguay

ABOUT
Bulb. Pale blue or lavender star-shape flowers in April; long-lasting bloom. Strap-like foliage reappears in fall and lasts through winter. Easy, trouble-free plants that spread and naturalize or can be divided after flowering. Cultivars available.

SIZE
4 – 6" tall
8" spread

SOIL
Well drained

PROPAGATION
Self-seeds or divide after flowering

SUN
Sun to partial shade
Zones 5–9

 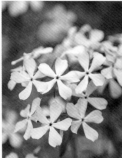 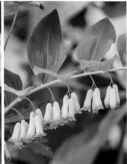 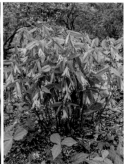 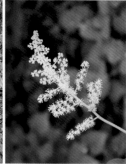

Mertensia virginica

· Virginia bluebells
· Boraginaceae

ORIGIN
Eastern U.S.

ABOUT
Easy-to-grow wildflower. Oval leaves appear early, followed by pink buds that turn to nodding, blue flowers. Dies down in summer.

SIZE
1 – 2′ tall
Equal spread

SOIL
Moist, well drained

PROPAGATION
Self-sows; also division of tubers in fall

SUN
Partial shade
Zones 3–8

Phlox divaricata

· Wild blue phlox
· Polemoniaceae

ORIGIN
Eastern North America

ABOUT
Herbaceous perennial. Dark green leaves; fragrant, lavender blue, 5-petal flowers. Cultivars have been selected for shades of blue and white flowers.

SIZE
12 – 15″ tall
12″ spread

SOIL
Moist, well drained

PROPAGATION
Self-sows, spreads by rhizomes and roots at nodes

SUN
Partial shade to sun
Zones 3–8 (9)

Polygonatum biflorum

· Solomon's seal
· Asparagaceae

ORIGIN
Eastern North America

ABOUT
Herbaceous perennial. Large, oval leaves alternate along an arching stem. Pairs of greenish white, bell-shape flowers hang at leaf nodes. Look for the "seal" on the rhizomes.

SIZE
1 – 3′ tall
1 – 2′ spread

SOIL
Moist

PROPAGATION
Division in fall
Seed

SUN
Partial shade to shade
Zones 3–8 (9)

Uvularia grandiflora

· Large-leaf bellwort
· Colchicaceae

ORIGIN
Eastern North America

ABOUT
Herbaceous perennial. Pendulous yellow bell-shape flowers at the ends of arching stems.

SIZE
1 – 2′ tall
1 – 1½′ spread

SOIL
Moist

PROPAGATION
Division, seed

SUN
Partial shade to shade
Zones 4–9

Smilacina racemosa

· False Solomon's seal

For detailed information, see "Winterhazel Walk," p. 30.

AZALEA WOODS

April to May

One of the highlights of the azalea season is the full flowering of the eight-acre Azalea Woods in early May. Started as a small nursery in 1917, this area has grown into a colorful maze whose flowering time is a favorite for many visiting Winterthur. In the shelter of old-forest trees, we find clouds of white dogwood blossoms (*Cornus florida*). Below these, azaleas produce waves of color and broadleaf rhododendrons soon add their exquisite flowers in shade of pink, lavender, red, and white. A medley of wildflowers and ferns covers the woodland floor.

Surprisingly few azalea cultivars—mainly Kurumes—make up Azalea Woods. Du Pont planted large masses of each cultivar and repeated his favorites in Azalea Woods and throughout the garden. He juxtaposed harmonious pastels; combined lighter and darker

(left) Lavender and cherry red azaleas "chic it up."

(right) Spanish bluebells with shades of pink-salmon azaleas.

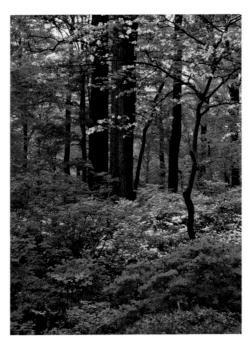

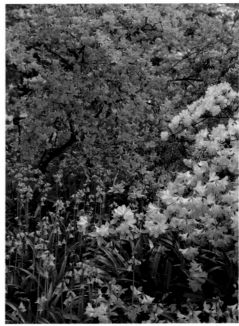

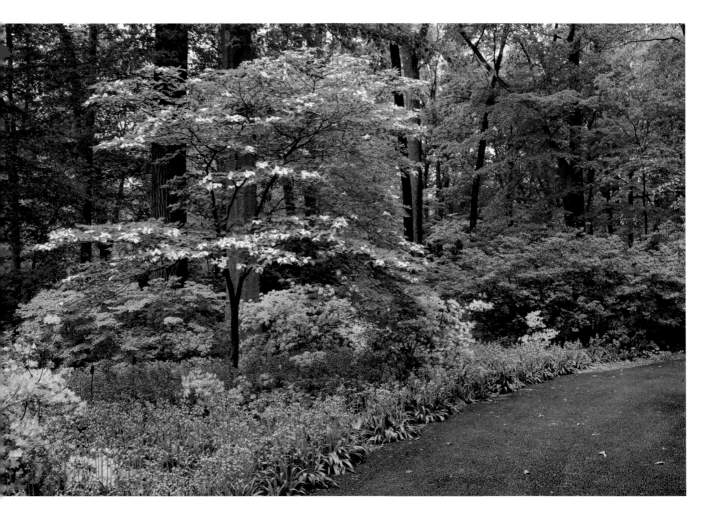

shades of the same color; blended textures of the same color (two whites, for example); and in some cases mixed two colors, near discords, that make us look twice. When asked about these unusual combinations, such as lavender and cherry red, du Pont replied that they would "chic it up." Along several paths, large broad-leaf rhododendrons produce spectacular displays of

delicately colored trusses. Torch azaleas (*Rhododendron kaempferi*) create a colorful corridor of orange, red, and salmon into this magical display. Du Pont underplanted the entire garden with thousands of brilliant Spanish bluebells (*Hyacinthoides hispanica*), which counterpoint the reds, pinks, corals, lavenders, and whites of the shrubs and add the finishing touch.

Kurume azaleas with a carpet of Spanish bluebells under a flowering dogwood welcome visitors to Azalea Woods.

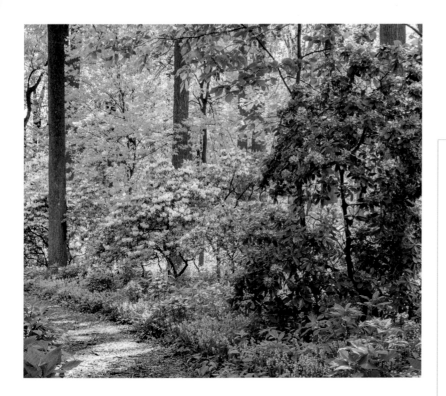

Broadleaf rhododendrons under tulip-poplars and oaks.

The principal forest trees that shade Azalea Woods include tulip-poplars, American beech, oaks, (*Quercus* species), and hickories. Wildflowers include trilliums (*Trillium grandiflorum*), Jacob's ladder (*Polemonium reptans*), primulas (*Primula elatior*), wild geranium (*Geranium maculatum*), and silvery glade fern (*Deparia acrostichoides*). Native plants, Japanese azaleas, hybrid rhododendrons, and Spanish bluebells all look perfectly at home in this American woodland garden. 🌱

Paths

Paths are an important tool in garden design. They invite us in as they curve to points out of sight. As we stroll, the garden is presented as a series of views.

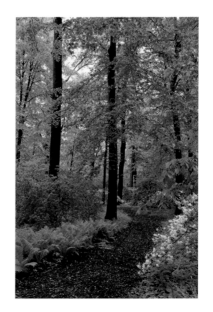

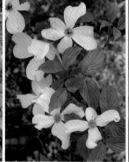
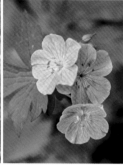

In Your Garden

To replicate the plantings in Azalea Woods, a large tree or, better still, a group of two or three can be a starting point. Oaks are ideal in supplying the necessary acidic soil (see *Quercus rubra*), but other deciduous trees will work. In their shelter, you might plant one or two white dogwoods and a few May-flowering azaleas of the same cultivar and then underplant the area with Spanish bluebells. Dogwoods grow naturally at the edge of woods and need good light and air circulation to thrive. The azaleas will appreciate the shade of the trees, and Spanish bluebells will flower in sun or shade at the same time as the azaleas. Add a few trilliums, wild geraniums, primulas, or ferns to enhance and carry the color to the woodland floor.

Deparia acrostichoides

Athyrium thelypterioides

· Silvery glade fern
· Athyriaceae

ORIGIN
Eastern U.S.

ABOUT
Herbaceous perennial. Light-green, lacy fronds. Spreads.

SIZE
2 – 3' tall
Equal spread

SOIL
Moist, rich in humus, or moist sandy

PROPAGATION
Division

SUN
Shade to partial shade
Zones 4–8

Cornus florida

· Flowering dogwood
 Cornaceae

ORIGIN
Eastern U.S. and Mexico

ABOUT
Deciduous tree; beautiful horizontal branching habit. In early spring, showy white bracts surround the true flowers, helping make this an all-time favorite native tree. Excellent fall foliage, fruit. Innumerable cultivars.

SIZE
20 – 40' tall
Equal spread

SOIL
Acid, moist, well drained, high organic

PROPAGATION
Softwood cuttings

SUN
Partial shade to full sun
Zones (5) 6–9

Geranium maculatum

· Wild geranium
· Geraniaceae

ORIGIN
Eastern North America

ABOUT
Herbaceous perennial. Rose lavender flowers arise in spring from a clump of palmately lobed leaves. Sometimes called cranesbill because of seedpod shape.

SIZE
12 – 20" tall
Equal spread

SOIL
Moist, acid to neutral

PROPAGATION
Seed, division

SUN
Sun to partial shade
Zones 3–8 (9)

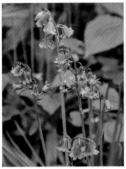
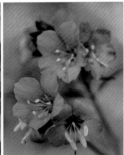
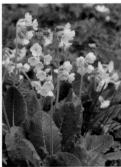

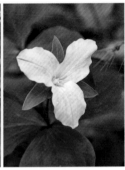

Hyacinthoides hispanica

· Spanish bluebells
· Asparagaceae

ORIGIN
Europe,
North Africa

ABOUT
Bulb. Bells of rich
lavender blue in
mid-spring; stems
arise from a clump
of strap-like leaves.
Cultivars available.

SIZE
12 – 15″ tall
12″ spread

SOIL
Well drained

PROPAGATION
Division of clumps
in fall, seeds

SUN
Sun to partial or
deeper shade
Zones 4–7

Polemonium reptans

· Jacob's ladder
· Polemoniaceae

ORIGIN
Eastern North
America

ABOUT
Herbaceous perennial.
Attractive foliage
resembles a ladder.
Soft blue flowers
bloom in mid-spring.
Naturalizes.

SIZE
8 – 18″ tall
12 – 14″ spread

SOIL
Moist, humus rich

PROPAGATION
Seed and division

SUN
Partial shade
Zones (2) 3–7 (8)

Primula elatior

· Oxlip primrose
· Primulaceae

ORIGIN
Europe

ABOUT
Herbaceous perennial.
Clusters of nodding,
pale yellow flowers on
stems that arise from a
clump of green leaves
in early spring.

SIZE
8″ tall
Equal spread

SOIL
Moist, humus rich

PROPAGATION
Division, seed

SUN
Partial shade
Zones 5–7

Quercus rubra

· Red oak
· Fagaceae

ORIGIN
Northern and Eastern
U.S. and Canada

ABOUT
Deciduous, fast-
growing, trouble-
free tree; easily
transplanted. Good
choice for home
gardeners desiring
a sheltering tree
for azaleas or
rhododendrons.

SIZE
60 – 75′ tall
Nearly equal spread

SOIL
Well drained, light,
slightly acid

PROPAGATION
Seed

SUN
Sun
Zones 4–7 (8)

Trillium grandiflorum

· Great white trillium
· Melanthiaceae

ORIGIN
Eastern North
America

ABOUT
Herbaceous perennial.
Upright stems carry
three leaves and white,
three-petal flowers in
spring. Flowers slowly
turn pink. Many other
species of trillium,
some rare, grow in the
woodlands here.

SIZE
18 – 24″ tall
12 – 18″ spread

SOIL
Moist, well drained

PROPAGATION
Division in early fall

SUN
Partial shade
Zones (3) 4–7 (8)

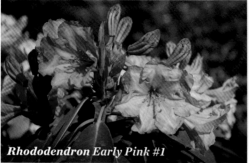

Rhododendron Early Pink #1

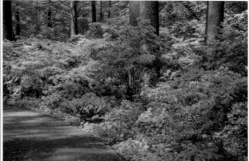

Rhododendron

· Azalea and Rhododendron
· Ericaceae

ABOUT
Grouped here are the Torch azalea, Kurume azaleas, and broadleaf, evergreen rhododendron cultivars. Individual cultivars vary in adaptability to geographic/floristic regions and hardiness. Check for plant and flower-bud hardiness when selecting for your garden.

SOIL
Acid, rich organic, moist, well drained

SUN
Partial shade

For pruning and propagation information, see "Other Azaleas and Rhododendrons," p.72.

NOTE
Taxonomists classify azaleas botanically as *Rhododendron*, so you will find Kurume azaleas listed under *Rhododendron*. In practice, however, gardeners and tradespeople routinely call certain plants azaleas and others rhododendrons (as in this book). In general, azaleas are shrubs with many individual blossoms and small leaves, whereas rhododendrons are shrubs with blossoms in trusses and whorls of large evergreen leaves. Furthermore, azaleas usually have five stamens and funnel-form blossoms; rhododendrons usually have ten or more.

Kurume Hybrids

ORIGIN
Japan

ABOUT
Evergreen, spreading shrubs covered with funnel-form blossoms that appear in mid-spring. Small, dark green leaves; flowers in many colors—whites through pinks, corals, lavenders to reds. Although some Kurumes in Azalea Woods are known only by du Pont's identifying numbers, substitutes are available. For example, his #10 is similar to '**Blaauw's Pink**,' a salmon pink hose-in-hose. Named cultivars in Azalea Woods include '**Pink Pearl**,' luminescent hose-in-hose, pink with light centers; '**Cherryblossom**,' light pink hose-in-hose with glossy leaves; '**Snow**,' vigorous, white hose-in-hose; '**Lavender Queen**,' free-flowering, light lavender single; '**Mauve Beauty**,' free-flowering, mauve hose-in-hose; and '**Arnoldiana**' (*R. obtusum amoenum* x *kaempferi* 'Arnoldiana'), cherry red.

SIZE
All range in size from
3 – 8' tall, 4 – 10' spread

SUN
Partial shade
Zones 6–8 (9)

Rhododendron kaempferi

· Torch azalea

ORIGIN
Japan

ABOUT
Evergreen to semi-evergreen, upright shrub. One of the hardiest evergreen azaleas. Flowers in early May in a color range of salmons, orange, pinks, and reds. White forms are also available.

SIZE
6 – 10' tall
4 – 6' spread

SUN
Partial shade
Zones 5–7

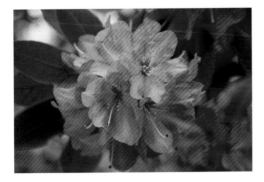

Broadleaf Evergreen Rhododendron Cultivars

ORIGIN
Parentage varies

ABOUT

· **'Ben Moseley'**
 a light purplish pink with dark blotch

· **'County of York'**
 upright white trusses of good
 substance and heat resistance

· **'Goldfort'**
 light yellow, adaptable

· **'Janet Blair'**
 delicate, frilled, pink flowers,
 easy to grow, widely adapted

· **'Scintillation'**
 pink, excellent flowers, foliage,
 and habit—deservedly popular

· **'Skyglow'**
 peach colored, edged pink, greenish blotch

Du Pont's "cherry red" rhododendron, which
figures prominently in Azalea Woods, is known
only as Dexter #11. It is similar to **'Wissahickon,'**
a Dexter hybrid sometimes available in the trade.

SIZE
All range in size from
5 – 6' tall, equal spread

SUN
Partial shade
Zones 5–9 (10)

An Amazing Genus

*"I do not know when I have enjoyed anything
more and have come back fired with a desire
to plant azaleas in all directions."*

H. F. DU PONT TO CHARLES DEXTER · JUNE 7, 1930

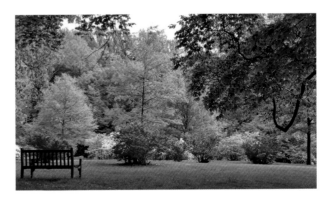

Henry Francis du Pont had just returned from
a visit to Charles Dexter, a prominent early
twentieth-century *Rhododendron* breeder. Mr.
du Pont had been planting azaleas and
rhododendrons at Winterthur as early as 1905 and
would continue to add them as botanists discovered
new species and nurseries bred new hybrids.
He wrote in the 1962 *Quarterly Bulletin of the
American Rhododendron Society*, "The longer I grow
azaleas, the more I realize how beautiful they are
when grouped in harmonious colors and pleasing
contrast. They naturalize in every imaginable
terrain and contour (no other species are in bloom
in Delaware for almost four months) and due
to their various height and habit of growth are
never monotonous, and are perfect with countless
varieties of bulbs and wild bloom."

OTHER AZALEAS & RHODODENDRONS

April to July

Azaleas and rhododendrons are truly the backbone of Winterthur's spring garden, flowering from early April until early August. Du Pont capitalized on this bounty and repeated favorites in several areas, providing unity to the garden through echoing colors and recurring motifs. Many of these good growers fall naturally into other sections of this book. Included here are additional plants of value to the home gardener.

In late April and early May, the delicate flowers of the royal azalea (*R. schlippenbachii*) glow against the evergreens of the Pinetum. This tall, deciduous shrub features large, soft pink blossoms that have been likened to alighting butterflies. Other azaleas here continue the pink theme, including the Wheeldon hybrid 'Miss Susie.' Glenn Dale hybrids (namely, 'Mayflower,' salmon) and several Chisholm Merritt hybrids (including 'Millicent' and 'Flower Queen') fill the Pinetum with color in early May.

Slightly later in the month, snow azalea (*R. mucronatum*) and variations of it flower throughout the garden. In the Sundial Garden, large, white, single flowers of snow azalea appear near the lavender-tinted cultivar 'Amethystinum.' The white, strawberry-throat cultivar 'Magnifica' blooms at Magnolia Bend, at the Reflecting Pool, in Azalea Woods and Peony Garden, and other areas as well. *Rhododendron mucronatum* and its cultivars often put out "sports," branches whose flower color differs from the rest of the plant. One, a soft lavender with lovely fragrance, was special enough to be propagated here and given the name 'Winterthur.' Large plantings of this

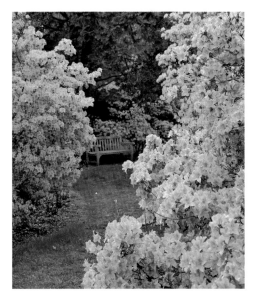

The hybrid 'Miss Susie' adds a bright pink note to the Pinetum in early May.

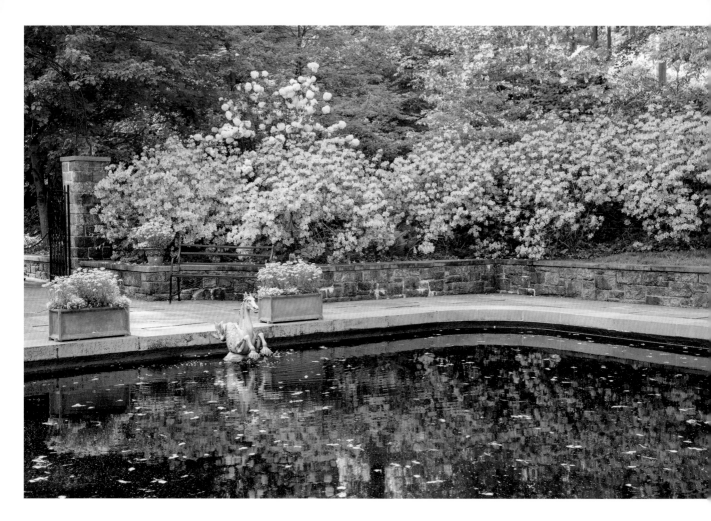

Rhododendron mucronatum 'Winterthur' and Chinese snowball viburnum flower beside the Reflecting Pool.

azalea appear in Enchanted Woods, on Oak Hill, and at the Reflecting Pool.

Hybrids of the Torch azalea (*R. kaempferi*) overlap with the flowers of *R. mucronatum* and extend the flowering time into late May. These hybrids come in shades of pink, salmon, and red and color the woodlands around the Icewell Terrace and

Enchanted Woods. A low-growing form with salmon flowers was selected here and also named 'Winterthur.' In early June along Clenny Run, magnificent rosebay rhododendron hybrids (*R. maximum* hybrids) flower in soft shades of lavender and pink. True to their name, they are enormous, stately, and spectacular and would be outstanding for a large site.

Throughout spring, native azaleas flower in the Pinetum and on Oak Hill. These deciduous plants with honeysuckle-like blossoms (sometimes called bush honeysuckle) come in colors that recall fruit sherbets. Two early-flowering species are the delicate Piedmont azalea (*R. canescens*) with white or pink flowers and the highly rated Florida azalea (*R. austrinum*) in shades of yellow and orange. Sweet-smelling coast azalea (*R. atlanticum*), an excellent white, blooms in May. In June white Alabama azalea (*R. alabamense*) appears, flame azalea (*R. calendulaceum*) colors the woods in orange, yellow, and red tones; and, a week or two later, Cumberland azalea (*R. cumberlandense*) flowers in reddish orange. In July and August, a large planting of coral-color, plum-leaf azalea (*R. prunifolium*) brightens a hillside above the Quarry Garden. As these native azaleas have become better known, various cultivars with special properties have been selected and are available in the trade. Hybridizers have used the American species as parents of many delightful deciduous hybrids, such as Ghent and Exbury azaleas. Many other species, hybrids, and cultivars appear in smaller numbers throughout the garden. 🜲

Kaempferi hybrid azaleas flowering below Icewell Terrace.

Deciduous azaleas flowering with Spanish bluebells in the Pinetum.

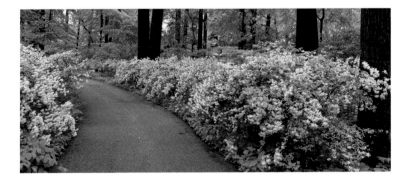

In Your Garden

Large-leaf evergreen rhododendrons, with their huge trusses, add enormously to any garden. Their grand scale requires the accompaniment of large trees or tall buildings. They look appropriate and comfortable in woodland settings, under deciduous trees in island beds, or with pines or other conifers. Small-leaf rhododendrons and evergreen azaleas are easier to incorporate into plantings around the foundation of a home, and they can also tolerate more sun. Deciduous azaleas, being rather informal, add both grace and delicacy to a woodland setting; they also provide variety and color to a shrub border, island bed, or conifer collection. Most rhododendrons and azaleas look their best and grow well in dappled shade.

Rhododendron

· Azalea and Rhododendron
· Ericaceae

ABOUT

Grouped here is a selection of evergreen and deciduous rhododendrons and azaleas. The term evergreen in this context is only an approximation; evergreen azaleas are more accurately called persistent leaved. Many have two sets of leaves: spring leaves often drop in the fall; summer leaves may remain during the winter, depending mostly on climate.

Prune large-leaf rhododendrons in early spring; cut back to one of the recent rosettes of leaves, cutting about one-quarter inch above the rosette. If more drastic pruning is needed for rejuvenation, about one-third of the growth should be removed yearly for three years. Prune small-leaf rhododendrons, evergreen azaleas, and deciduous azaleas after flowering; cut just above a side branch. It is best to reach down into the shrub when cutting so that the stub is covered by other branches.

SOIL

(for all) Acid, moist, well drained, organic

PROPAGATION

For propagation of large-leaf evergreen rhododendrons, take cuttings after new growth shows firmness. For propagation of evergreen azaleas, take softwood cuttings in summer. For propagation of deciduous azaleas, take softwood cuttings early in the season.

SUN

Partial shade

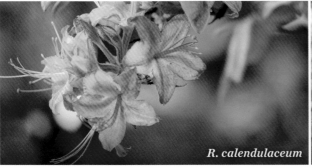
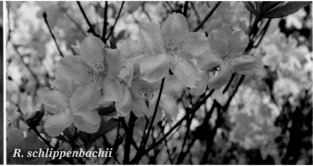

R. calendulaceum *R. schlippenbachii*

Deciduous Azaleas

A selection of deciduous azaleas offers fragrance, a variety of colors, and flowering times from mid-April to July.

R. cumberlandense
· Cumberland azalea

ORIGIN
Kentucky to Georgia

ABOUT
Orange to red funnel-form flowers open in early summer, after the leaves.

SIZE
3 – 8' tall, equal spread

SUN
Zones 5–7

R. austrinum
· Florida azalea

ORIGIN
Florida, Georgia

ABOUT
Fragrant yellow to orange-red flowers in May.

SIZE
6 – 10' tall
Equal spread

SUN
Zones 6–9

R. canescens
· Piedmont azalea

ORIGIN
Pennsylvania to Texas

ABOUT
Fragrant pink to white flowers in May.

SIZE
6 – 15' tall
6 – 10' spread

SUN
Zones 5–9

R. luteum
· Pontic azalea

ORIGIN
Europe, Caucasas

ABOUT
Fragrant yellow flowers in May.

SIZE
4 – 5' tall
Equal spread

SUN
Zones 6–9

R. calendulaceum
· Flame azalea

ORIGIN
Pennsylvania to Georgia

ABOUT
Upright shrub. Funnel-form flowers in yellow, orange, or red open with or after the leaves in early summer. Many cultivars.

SIZE
6 – 10' tall
Equal spread

SUN
Zones 5–7

R. atlanticum
· Coast azalea

ORIGIN
Delaware to South Carolina

ABOUT
White flowers, often with pink tube, open with the leaves in late spring. Blue-green foliage. Stoloniferous. Cultivars available.

SIZE
3 – 6' tall
Equal spread

SUN
Zones 5–8 (9)

R. alabamense
· Alabama azalea

ORIGIN
Alabama, Georgia

ABOUT
White, fragrant flowers, in clusters of 6–10, open with the leaves in early summer.

SIZE
5 – 6' tall
8' spread

SUN
Zones 7–8

R. schlippenbachii
· Royal azalea

ORIGIN
Korea, Manchuria

ABOUT
Upright shrub. Delicate pink flowers with flaring petals. Mid-spring. Broad, rounded leaves, seemingly arranged in whorls, appear with, or just after, the flowers.

SIZE
6 – 8' tall, equal spread

SUN
Zones 4–7

R. prunifolium
· Plum-leaf azalea

ORIGIN
Georgia, Alabama

ABOUT
Large, spreading shrub. Orange-red flowers in July. Cuttings root readily. Cultivars available.

SIZE
8 – 10' tall
Equal spread

SUN
Zones 5–8 (9)

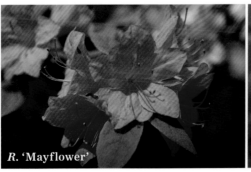

R. 'Mayflower'

Evergreen Azaleas

*Four evergreen azaleas
in the Pinetum offer
pink flowers and
mid-spring bloom. If
these are hard to find,
'Blaauw's Pink,' may be
substituted for any.*

SUN
Partial shade for all

'Flower Queen'

ABOUT
Chisholm Merritt
introduction; pink.

SIZE
5' tall, equal spread

SUN
Zones 7–9

'Mayflower'

ABOUT
Glenn Dale
introduction; large,
salmon pink flowers.

SIZE
8' tall, equal spread

SUN
Zones 6–9

'Millicent'

ABOUT
A Chisholm Merritt
introduction; pink.

SIZE
5' tall, equal spread

SUN
Zones 7–9

'Miss Susie'

ABOUT
Wheeldon
introduction;
bright pink.

SIZE
5 – 6' tall, equal spread

SUN
Zones 7–9

'Blaauw's Pink'

ABOUT
Kurume. A
dependable, salmon
hose-in-hose.

SIZE
5' tall, equal spread

SUN
Zones 6–8 (9)

R. kaempferi hybrids

· Torch azalea hybrids

ORIGIN
Species from Japan

ABOUT
Evergreen, upright
shrub. The flower
forms at Winterthur
range from pink and
salmons to reds.
White forms are
available. One of the
hardiest azaleas.

SIZE
8' tall

SUN
Zones 5–8

R. mucronatum and cultivars

· Snow azalea

ORIGIN
Japan

ABOUT
Spreading evergreen
shrub. Large, pure
white flowers in late
spring. Sometimes
listed as *R. ledifolium.*
Substitute could be
'Delaware Valley
White,' a derivative
(3' tall).

CULTIVARS
'Amethystinum,'
palest lavender;
'Magnifica,' white
with strawberry
throat; and
'Winterthur,'
fragrant lavender
flowers

SIZE
(for all) 6' tall,
6 – 8' spread

SUN
Zones 6–9

Evergreen Rhododendrons

R. maximum hybrids

· Rosebay
 rhododendron
 hybrids

ORIGIN
Species: Eastern U.S.

ABOUT
Large shrubs.
Handsome, lavender
and pinkish lavender
trusses in early
summer. Cold hardy.
Appreciate cool
conditions.

SIZE
12 – 30' tall
Equal spread

SUN
Zones 3–7

Peony Garden

Quarry Garden

Sycamore Hill

SPRING *into* SUMMER

In May, azaleas and rhododendrons are the major players in the Winterthur garden; however, there are many other flowering plants that du Pont used to color the late spring garden and to extend the floral display into summer. The Peony Garden offers a collection that flowers from early May to early summer while the Quarry Garden features primroses spanning from May to June. Du Pont also used the sunny slopes of Sycamore Hill to enhance his collection of late-May-to-summer flowering shrubs and trees.

PEONY GARDEN

May

Peonies (*Paeonia* hybrids and species) are one of nature's gifts to gardeners. Their colors range from whites and pinks to yellows and glowing reds. Many have handsome yellow "bosses" of stamens. Ease of culture, hardiness, and longevity add to the appeal of these plants, as does the handsome green foliage that lasts all summer.

In his Peony Garden, H. F. du Pont honored the work of Dr. Percy A.

Saunders, one of the great peony hybridizers of the twentieth century. In addition to herbaceous peonies, the garden features the lesser-known tree peony, which is also easy to grow. These have woody stems that do not die down in winter; yet, the term *tree* is misleading since they are actually shrubs that grow 4- to 6-feet tall. With petals of tissue-paper delicacy, often frilled and ruffled at the edges, blossoms may measure as much as

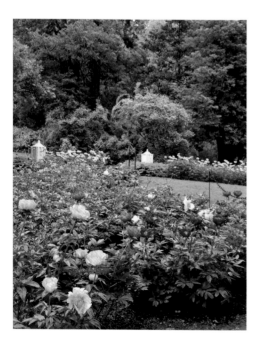

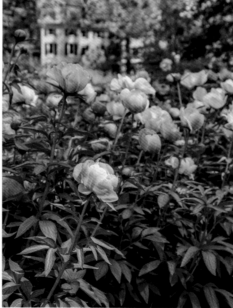

(left) Saunders peonies in a range of pinks surround the white decorative beehives. Pink Coral Bells azaleas and beauty bush flower in the background.

(right) Herbaceous peony Paeonia 'Janice.'

8 inches across. Colors are varied, muted, and unusual, ranging from elegant whites, buffs, pinks, peaches, and yellows to crimson, cerise, and deep maroon. An individual blossom may contain a combination of hues. By selecting specific cultivars, you can extend your peony flowering time into the first days of summer.

Du Pont added plants with similar flowering times, including the introduction of the beauty bush (*Kolkwitzia amabilis*), with its fountain of cascading pink blossoms. The lavender flowers of Chinese lilac (*Syringa* x *chinensis*) and Henry's lilac (*S.* x *henryi*) also work well here. Surrounding the garden are additional complementary plants. Pink *Weigela florida* var. *venusta*, flowering near the garden steps, harmonizes with the striking wine red azalea, *Rhododendron obtusum* 'Amoenum.' A pink crabapple named in honor of du Pont (*Malus* 'Henry F. du Pont') flourishes along the path to the Visitor Center. Kurume azalea Coral Bells (*Rhododendron* 'Coral Bells') line this same lawn path. ⚘

Magnifica and Coral Bells azaleas line the walk to the Peony Garden along with Malus 'Henry F. du Pont.'

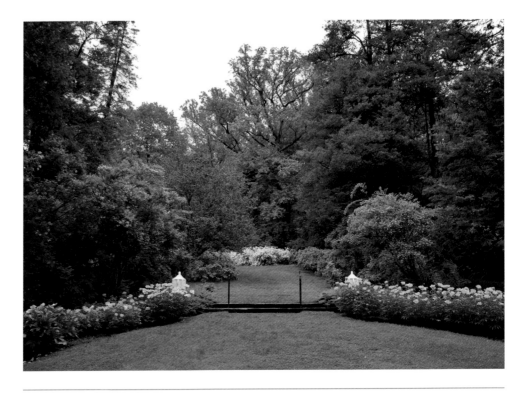

In Your Garden

It is usually easy to find a place for a few peonies. They will settle comfortably into a perennial bed or in the front of a shrub border. The lustrous, dark green foliage of herbaceous peonies is an asset, arriving early and lasting all summer. Fortunately, they are not a favorite of deer and rabbits and can last for decades. In northern climates, gardeners prize them for their cold hardiness. For southerly situations, early-flowering varieties are recommended. Tree peonies feature medium green, matte foliage. Their large blossoms need no staking, so the plant often resembles a big bouquet. Once established, tree peonies do not like to be moved; by contrast, herbaceous peonies can be divided. Both types provide wonderful cut flowers.

Kolkwitzia amabilis

· Beauty bush
· Caprifoliaceae

ORIGIN
China

ABOUT
Upright, deciduous shrub. Arching branches. Clusters of pink, flaring, tubular flowers in late spring. Prune after flowering.

SIZE
6 – 10' tall
4 – 8' spread

SOIL
Well drained, pH adaptable

PROPAGATION
Softwood cuttings

SUN
Sun
Zones 4–8

Malus 'Henry F. du Pont'

· Henry F. du Pont crabapple
· Rosaceae

ORIGIN
Hybrid

ABOUT
Low-spreading, deciduous tree. Single and semi-double pink flowers in mid-spring. Prune immediately after flowering.

SIZE
20 – 30' tall
25 – 35' spread

SOIL
Acid, moist, well drained

PROPAGATION
Softwood cuttings

SUN
Sun
Zones 4–7

Weigela florida

· Old-fashioned weigela
· Caprifoliaceae

ORIGIN
Japan

ABOUT
Deciduous, spreading shrub. Tube-like flowers in small clusters. Purplish pink. Variety *venusta* is more compact than the species. Many cultivars of the species. Early May bloom. Trouble free. Prune after flowering.

SIZE
6 – 9' tall
Equal spread

SOIL
Any good, not dry

PROPAGATION
Softwood cuttings

SUN
Sun to partial shade
Zones 4–8 (9)

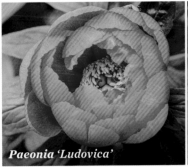
Paeonia 'Ludovica'

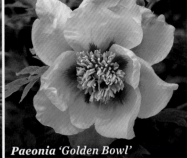
Paeonia 'Golden Bowl'

Rhododendron obtusum 'Amoenum'

Paeonia **Hybrids and Species**

· Peony hybrids
 and species
· Paeoniaceae

ORIGIN
Largely Asian
and European

ABOUT
Colors and forms
described above.
Almost unlimited
choices in catalogues.
Trouble free, very
long-lived. A few that
have done well at
Winterthur include:
· **'Janice'**
 in salmon pink that
 turns to palest pink
 (herbaceous)
· **'Ludovica'**
 deep pink,
 (herbaceous)
· **'Golden Bowl'**
 large yellow
 (tree peonies)
· **'Chinese Dragon'**
 deep red
 (tree peonies)

Herbaceous peonies

ABOUT
Plant in fall, with
eyes (buds) 2" below
soil surface in cold
climates, 1" below in
warm climates.

SIZE
2 – 3' tall
Equal spread

SOIL
Moist, well drained,
fertile, slightly acid

PROPAGATION
Once well established,
propagate in fall by
dividing roots, leaving
3 eyes on each section.

SUN
Sun, but will do well
in partial shade.
Zones 2–8, with some
qualifications at the
extremes

Tree peonies

ABOUT
Need three weeks of
temperatures 35–40°F
or below to undergo
dormancy. Mostly
offered grafted onto
herbaceous roots.
Plant in fall, with
graft union 3–4"
below surface.

SIZE
4 – 8' tall
Equal spread

SOIL
Well drained, fertile,
neutral

PROPAGATION
Cuttings taken in
September

SUN
Partial shade,
especially in South
Zones 4–7

Rhododendron

· Azalea
· Ericaceae

SOIL
Acid, moist, well drained, high organic

SUN
Partial shade

For detailed information, see
"Other Azaleas and Rhododendrons," p. 72.

Two azaleas are grouped here:

R. obtusum 'Amoenum'

· Amoenum azalea

ORIGIN
Japan

ABOUT
Spreading, evergreen
azalea; deep wine red
flowers in May.

SIZE
3' tall
Equal spread

SUN
Partial shade
Zones 6–8 (9)

R. 'Coral Bells'

· Coral bells
 Kurume azalea

ORIGIN
Japan

ABOUT
Evergreen azalea;
salmon pink hose-in-
hose flowers in May.

SIZE
3' tall
4' spread

SUN
Partial shade
Zones 6–8 (9)

Syringa chinensis

Syringa

- Lilac
- Oleaceae

ABOUT
Two lilacs are found here; one blooms in early May, the other in late May. Both deciduous. Prune soon after flowering by cutting old canes close to ground.

SOIL
Neutral, pH adaptable, well drained

PROPAGATION
Softwood cuttings

SUN
Sun

S. x chinensis

- Chinese lilac
- Rouen lilac

ABOUT
Arching branches with lavender flowers early in May. Delicate in appearance.

SIZE
8 – 15′ tall
Equal spread

SUN
Zones 3–7

S. x henryi

- Henry's lilac

ABOUT
Large, spreading shrub; lavender flowers in late May. Valuable as a late bloomer. Cold hardy.

SIZE
10′ tall
Equal spread

SUN
Zones 2–7 (8)

Special Attractions

What would the Peony Garden be without the Latimeria Summer House or decorative beehives?

H. F. du Pont collected many objects for his garden and had structures made as well. Such artifacts become an important part of the design, adding focal points, year-round interest, and places from which to rest and enjoy the garden.

QUARRY GARDEN

May to August

In 1962, H. F. du Pont transformed an abandoned stone quarry into a romantic garden, a remarkable demonstration of his talent for realizing the potential of a site. The landscaping of surrounding areas had begun to surround this open pit, and du Pont had long wished for a damp location where he could grow primulas. With notable ingenuity, he created the massive rock garden that we know today as the Quarry Garden. Visitors can look down on the Quarry Garden from several vantage points. Better yet, they can descend stone steps into the garden. Trailing shrubs, ferns, and other herbaceous plants spill out of crevices in the stone walls. Paths and places to sit appear at lower levels. The lowest level is boglike, and springs feed three gentle streams that meander along the garden floor, creating ideal conditions for moisture-loving primulas, iris, and other bog plants.

Two azaleas flower here in mid-May, giving promise of the color soon to unfold on the quarry floor. Flanking the steps, diminutive *R. kiusianum* flowers in lavender, while along the walls, *R.* x *mortieri* blossoms in soft coral. In late May, the floor becomes a quilt of candelabra primulas (*Primula* species and hybrids), or primroses. Blooming in unusual, muted colors—plum, apricot, coral, yellow, lavender, pink—their subtle shades blend beautifully. These primulas are characterized by blossoms clustered around the stem in whorls arranged in tiers, hence the name *candelabra*. The blossoms open one tier after another, resulting in a long bloom period. A shady streamside in the home garden would be ideal for these plants. In any situation, however, they need moisture during the summer. Another candelabra found at Winterthur is Japanese primrose (*P. japonica*), which comes in reds, pinks, whites, and mixtures of these colors. It grows along streams. This primrose is easy to grow, aggressive, and tends to crowd out other candelabras; therefore, its numbers in the Quarry Garden are carefully monitored. Off by itself, it is welcome to spread.

Irises growing here are also adapted to wet conditions and introduce lavender to the color scheme. The rocks, crevices, and shade make an ideal setting for various naturalized plants as well. Among them is the delicate fern-leaf

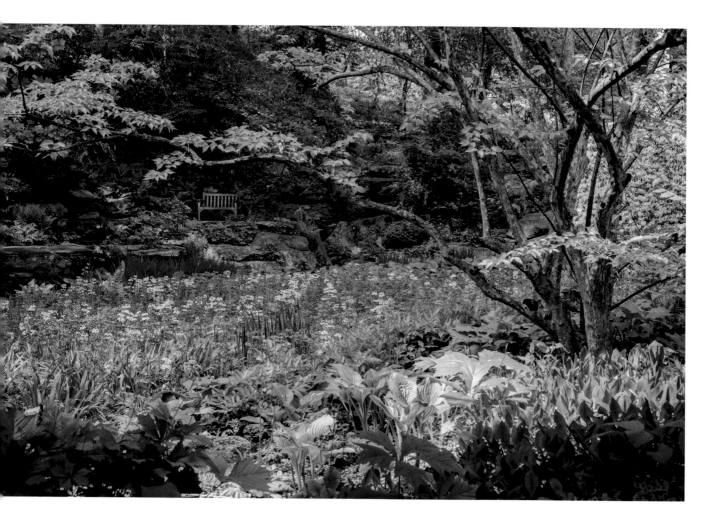

corydalis (*Corydalis cheilanthifolia*), whose yellow flowers appear in April, along with the yellow and purple flowers of different barrenworts, also known as fairy wings (*Epimedium* sp.).

In July and August, lobelias attract butterflies and birds. The bright red spires of the cardinal flower (*Lobelia cardinalis*) are among their favorites,

certainly of hummingbirds. Yet another handsome, tall specimen is big blue lobelia (*Lobelia siphilitica*), which is a delightful shade of purple. True blue is uncommon in the horticultural world, and purple and lavender plants are often called blue. These lobelias and others are the parents of various hybrids, resulting in a range of colors—including rose, lavender, purple,

Candelabra primroses on the Quarry Garden floor with pink flowers of Rhododendron x mortieri.

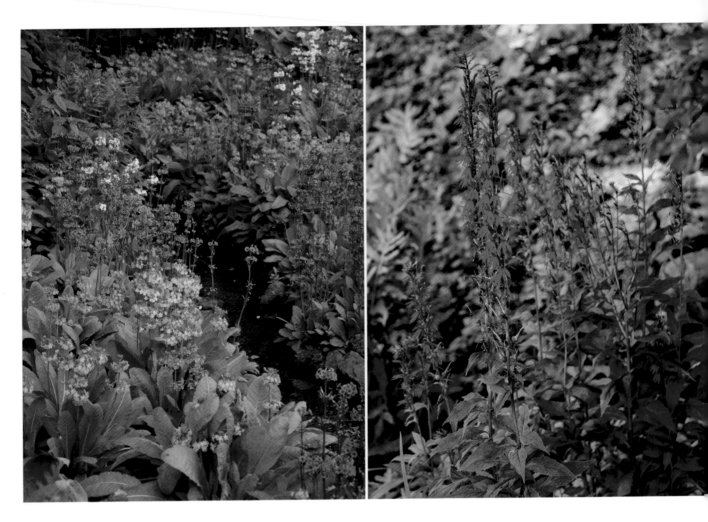

(left) Candelabra
primroses in soft,
muted tones.

(right) Lobelia
cardinalis blooms in the
Quarry Garden
and nearby.

and white—that offer more choices for
the moist, shady garden. Meanwhile,
a member of the great genus *Clematis*
flourishes on a slightly drier bank nearby.
Tube clematis (*Clematis heracleifolia*
var. *davidiana*), a sprawling sub-shrub,
has fragrant blossoms reminiscent of
hyacinths; the soft blue blooms appear in
late August and are a fine addition to the
late-summer garden.

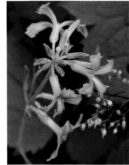

In Your Garden

If you have a semi-shady, damp spot—perhaps even a problem area—any or all of the plants described here are worth a try. Some of the primulas offer a starting place. If you want a plant that will take care of itself, given the right conditions, *Primula japonica* can be carefree. Some of these plants do not need bog conditions. Lobelias, for instance, are easy to grow in ordinary garden soil. *Clematis heracleifolia* is an appealing, sprawling shrub of lovely color that appears in late summer when our gardens may need a lift, and fern-leaf corydalis is ideal for crevices in a shady stone wall.

Clematis heracleifolia var. *davidiana*

- Tube clematis
- Ranunculaceae

ORIGIN
China

ABOUT
Deciduous, sprawling sub-shrub. Blue, hyacinth-like flowers in late summer. Prune in spring.

SIZE
2–3′ tall
3′ spread

SOIL
Moist but not boglike

PROPAGATION
Self-sows or by terminal cuttings in summer

SUN
Sun
Zones 3–7

Corydalis cheilanthifolia

- Fern-leaf corydalis
- Fumariaceae

ORIGIN
China

ABOUT
Herbaceous perennial. Ferny foliage. Yellow flowers with turned-up spurs along upright stems in early spring.

SIZE
9–12″ tall
12″ spread

SOIL
Rock crevices seem ideal; well-drained, good garden soil

PROPAGATION
Self-sows or division

SUN
Partial shade to shade
Zones 3–6

Iris hexagona

- Dixie iris
- Iridaceae

ORIGIN
South Carolina to Gulf States

ABOUT
Herbaceous perennial. Purple flowers with yellow markings in late spring. Grows in swamps.

SIZE
2–3′ tall
2′ spread

SOIL
Moist, acid, rich organic

PROPAGATION
Division

SUN
Sun or partial shade
Zones 4–9

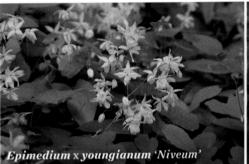
Epimedium x *youngianum 'Niveum'*

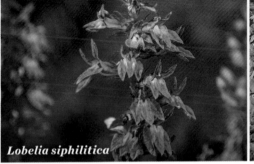
Lobelia siphilitica

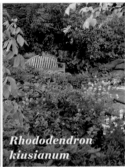
Rhododendron kiusianum

Epimedium

· Fairy wings
· Berberidaceae

ORIGIN
Eurasia

ABOUT
Herbaceous perennial; semi-evergreen to deciduous. Dainty blossoms of white, yellow, red, pink, lavender, or orange float above the leaves in early spring.

SIZE
6 – 24″ tall

PROPAGATION
Division

SOIL
Moist, well drained, will tolerate drought once established

SUN
Part sun to light shade
Zones 4–9

Epimedium x *versicolor* 'Sulphureum'

ORIGIN
Parents from Japan and Iran

ABOUT
Soft yellow.

SIZE
6 – 12″ tall
6 – 18″ spread

SUN
Part sun to light shade
Zones 5–9

Epimedium x *youngianum* 'Niveum'

ORIGIN
Parents from Japan

ABOUT
Pure white.

SIZE
6 – 12″ tall
12 – 18″ spread

SUN
Part sun to light shade
Zones 4–8

Lobelia

· Lobelia
· Campanulaceae

ORIGIN
North America

ABOUT
Herbaceous perennial. Short-lived. Midsummer bloom. Flowers bloom from bottom to top along tall stems.

SOIL
Moist, humus rich; will stand wet

SUN
Shade in South, shade to sun in North

PROPAGATION
Seed or division

L. cardinalis

· Cardinal flower

ABOUT
Brilliant red flowers attract hummingbirds.

SIZE
2 – 4′ tall
1′ spread

SUN
Zones (2) 3–9

L. siphilitica

· Big blue lobelia

ABOUT
Flowers in a lovely purple shade.

SIZE
2 – 3′ tall
1′ spread

SUN
Zones (3) 4–8 (9)

Rhododendron

· Azalea
· Ericaceae

SOIL
Acid, moist, well drained, high organic

R. kiusianum

· Kiusianum azalea

ORIGIN
Japan

ABOUT
Purple flowers cover this evergreen shrub in spring. Species sometimes pink or white.

SIZE
2′ tall, equal spread

SUN
Partial shade
Zones 6–8 (9)

R. x mortieri

· Mortieri azalea

ORIGIN
Parents from U.S.

ABOUT
Coral flowers in mid- to late spring.

SIZE
6′ tall, 5′ spread

SUN
Partial shade
Zones 5–8

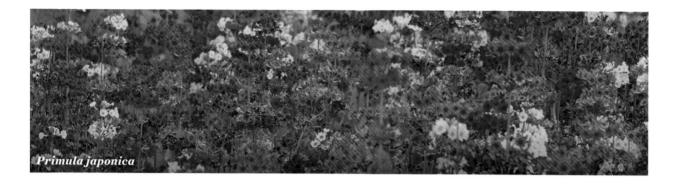
Primula japonica

Primula

· Primrose
· Primulaceae

ABOUT
Herbaceous perennials. Whorls of flowers in tiers around strong stems. Some hybrids are easier to grow than the species. Wide range of interesting colors. Late-spring bloom.

SOIL
Consistently moist, well drained, high organic

PROPAGATION
From seed (species); division after flowering (cultivars)

SUN
Partial shade (unless otherwise noted)

CANDELABRA PRIMROSES:

P. beesiana
· Bees primrose

ORIGIN
China

ABOUT
Lavender pink

SIZE
18 – 24″ tall, 24″ spread

SUN
Partial shade
Zones 6–8

P. x *bullesiana*
· Bulles primrose

ORIGIN
Parents from China

ABOUT
Cream, orange, pink, red, and purple

SIZE
2′ tall, equal spread

SUN
Partial sun, full sun in the North
Zones (5) 6–7 (8)

P. bulleyana
· Bulley's primrose

ORIGIN
China

ABOUT
Orange-yellow

SIZE
2 – 3′ tall, equal spread

SUN
Partial shade
Zones 6–8

P. pulverulenta
· Silverdust primrose

ORIGIN
China

ABOUT
Reddish purple. Easily grown. 'Bartley's Strain,' is a soft pink cultivar.

SIZE
30″ tall, equal spread

SUN
Partial shade
Zones 5–8

P. japonica
· Japanese primrose

ORIGIN
Japan

ABOUT
Red, pink, white, purple flowers. Aggressive; crowds out other candelabras. Cultivars available.

SIZE
12 – 24″ tall, 24″ spread

SUN
Partial shade
Zones 5–7

P. burmanica
· Burman primrose

ORIGIN
Burma

ABOUT
Reddish purple

SIZE
2′ tall, equal spread

SUN
Partial shade
Zones 6–8

PRIMULAS, NOT CANDELABRA, BUT BOG ADAPTABLE:

P. denticulata
· Drumstick primrose

ORIGIN
Himalayas

ABOUT
Flowers are lavender globes on upright stems that appear as leaves emerge.

SIZE
8 – 10″ tall, 12″ spread

SUN
Zones (3) 4–7 (8)

P. sieboldii
· Siebold primrose

ORIGIN
Japan

ABOUT
Purple, white, or rose clusters in late spring. White recommended. Can take more sun and less moisture than other species.

SIZE
6 – 12″ tall, 12″ spread

SUN
Zones (4) 5–8

SYCAMORE HILL

Late May to July

As May gives way to June, Sycamore Hill offers us blossoms in white, lavender, and red with touches of cream and shades of pink. Trees and shrubs grouped here repeat the color combinations of early spring and suggest options for our gardens. Named for a sycamore that is more than 200 years old, this area features plants that continue the bloom of the surrounding landscape. Late-flowering lavender lilacs (*Syringa*), white deutzia (*Deutzia*), mock orange (*Philadelphus*), and the white kousa dogwoods (*Cornus kousa*) produce overlapping waves of color and textural interest. Nearby a lavender azalea (*Rhododendron* 'Martha Hitchcock') and buddleia (*Buddleja alternifolia*) repeat the color of the lilacs, while wine red weigela (*Weigela* 'Eva Rathke') and red buckeye (*Aesculus pavia*) add contrasting notes. The bright wine red stamens of Oyama magnolia (*Magnolia sieboldii*) pick

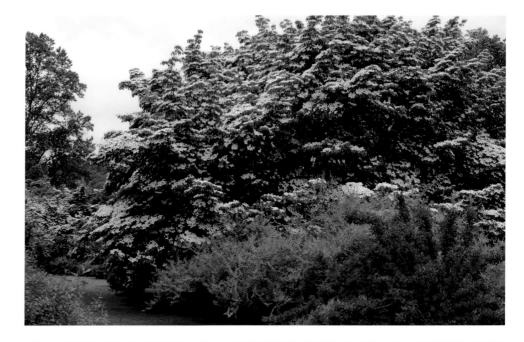

Kousa dogwood with lavender fountain buddleia and Weigela 'Red Prince' on Sycamore Hill.

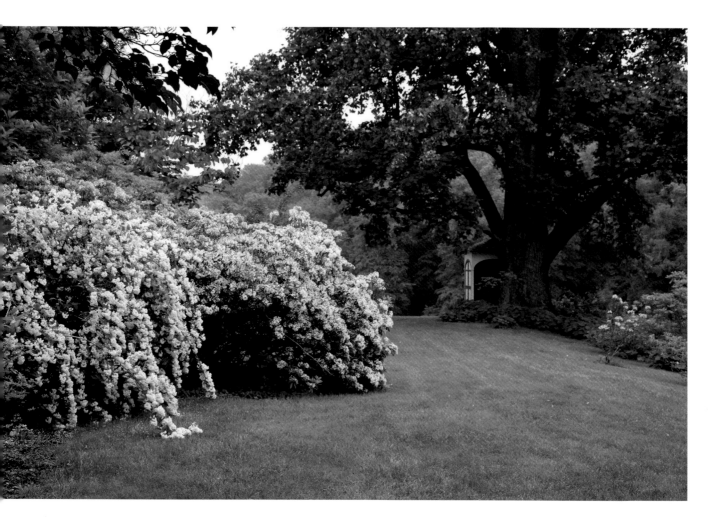

up the color of the weigela. Vibrant coral and pink azaleas (*Rhododendron* 'Homebush' and 'Pallas') expand the color palette.

At the Bristol Summer House, dusty pink blossoms of mountain laurel (*Kalmia latifolia*) echo pink old-fashioned roses (*Rosa* 'Pink Leda'). Later in June, deep pink spirea (*S.* x *margaritae*) combines with lavender-tinted *Deutzia chunii* and lavender *Leptodermis oblonga*. Blending well with all are the creamy blossoms of American fringe trees (*Chionanthus virginicus*) and Japanese tree lilacs (*S. reticulata*). Later in summer, stewartias (*Stewartia* species) flower in white. 🌱

White Deutzia x magnifica and pink Kalmia latifolia flowering in late May.

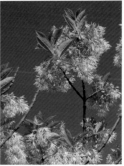

In Your Garden

Several trees stand out as especially valuable. The kousa dogwood, which du Pont sometimes called the June dogwood, has great arching branches covered with star-shape blossoms. A second period of interest comes during the fall berry season, when the trees are laden with raspberry-like fruit. The kousas are easy to grow and flower later than American dogwoods (*C. florida*). *Cornus* 'Rutlan' Ruth Ellen is a hybrid of the two that offers disease resistance and a flowering time that bridges the two species. Other valuable small trees for the home property include American fringe trees, whose creamy blossoms provide the "fringe" in late May, early June. Stewartias offer appealing architecture, delicate blossoms, unusual fruit, and lovely fall colors.

Aesculus pavia

· Red buckeye
· Sapindaceae

ORIGIN
North America

ABOUT
Deciduous shrub or tree. Attractive upright panicles of red flowers in late spring/early summer. A favorite of hummingbirds.

SIZE
12 – 25' tall
Equal spread

SOIL
Moist, well drained

PROPAGATION
Root cuttings, seed

SUN
Sun to partial shade
Zone 4–8

Buddleja alternifolia

· Fountain buddleia
· Scrophulariaceae

ORIGIN
China

ABOUT
Deciduous shrub. Arching branches covered with lavender flowers in late spring. Gray-green foliage. Trouble free. Prune after flowering.

SIZE
6' tall
Equal spread

SOIL
Loose, well drained

PROPAGATION
Softwood and hardwood cuttings

SUN
Sun
Zones 5–7

Chionanthus virginicus

· American fringe tree
· Oleaceae

ORIGIN
New Jersey to Florida, Texas

ABOUT
Deciduous shrub or tree. Handsome foliage. Creamy fringe-like flowers in mid-May. Prune after flowering.

SIZE
12 – 30' tall
Equal spread

SOIL
Acid, moist, well drained, high organic but adaptable

PROPAGATION
Seed, propagation difficult

SUN
Sun to partial shade
Zones 4–9

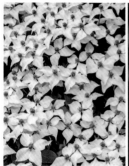
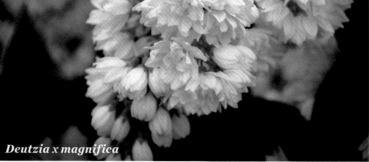

Deutzia x magnifica

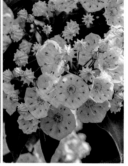

Cornus kousa

· Kousa dogwood
· Cornaceae

ORIGIN
Japan, Korea, China

ABOUT
Deciduous tree.
Outstanding bloom
in late spring or
early summer,
when white bracts
coat branches.
Trouble free.
Many cultivars.

SIZE
20 – 30′ tall
Equal spread

SOIL
Acid, moist,
well drained,
organically rich

PROPAGATION
Softwood cuttings

SUN
Sun to light shade
Zones 5–8

Deutzia

· Deutzia
· Hydrangeaceae

ABOUT
Prune after flowering.

SOIL
Good garden, pH
adaptable, needs
moisture

PROPAGATION
Softwood or
hardwood cuttings

SUN
Sun

Three deciduous deutzias are grouped here:

D. chunii

· Chunii deutzia

ORIGIN
Eastern China

ABOUT
Misty lavender
in bud, lightens
as flowers open.
Beautiful, arching
shrub; should be
better known
and grown.

SIZE
6 – 10′ tall
Equal spread

SUN
Sun to light shade
Zones 5–8

D. x magnifica

· Showy deutzia

ORIGIN
Parents from Japan
and China

ABOUT
Double, white
flowers in short,
dense panicles.
Arching shrub.

SIZE
6 – 10′ tall
Equal spread

SUN
Sun to light shade
Zones 5–8

D. scabra

· Fuzzy deutzia

ORIGIN
Japan, China

ABOUT
Oval shrub;
arching branches.
White flowers in
upright panicles.
Cultivars include
double flowers.

SIZE
6 – 10′ tall
4 – 8′ spread

SUN
Sun to light shade
Zones 5–7 (8)

Kalmia latifolia

· Mountain laurel
· Ericaceae

ORIGIN
Eastern U.S.

ABOUT
Evergreen shrub;
rather slow growing.
Distinctive, pink
flowers in round
clusters. Handsome,
leathery leaves. A
favorite native plant.
Prune after flowering.
Many new cultivars,
pink through red.

SIZE
6 – 10′ tall
Equal spread

SOIL
Acid, cool, moist,
well drained

PROPAGATION
Tissue culture, seed

SUN
Sun to shade
Zones 4–9

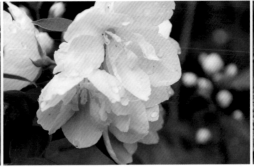
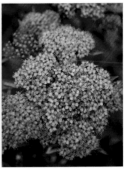

Leptodermis oblonga

· Chinese leptodermis
· Rubiaceae

ORIGIN
Asia

ABOUT
Low, mounded, deciduous shrub. Flowers appear as rosy lavender tubes with open faces in early summer. Prune after flowering.

SIZE
3 – 4′ tall
4′ spread

SOIL
Good garden

PROPAGATION
Seed or softwood cuttings

SUN
Sun
Zones (4) 5–8

Magnolia sieboldii

· Oyama magnolia
· Magnoliaceae

ORIGIN
Eastern Asia

ABOUT
Deciduous, spreading shrub. Nodding pure white egg-shape flower buds open to reveal striking red cluster of stamens. Best when viewed from walking under blossoms in late May, early June.

SIZE
10 – 15′ tall
Equal spread

SOIL
Moist, slightly acidic

PROPAGATION
Seed, cuttings or layering

SUN
Sun to partial shade
Zones 6–8

Philadelphus

· Mock orange
· Hydrangeaceae

ABOUT
Deciduous shrub. White, fragrant blossoms in early summer. Easy. Prune after flowering.

SOIL
Adaptable

SUN
Sun to light shade

PROPAGATION
Softwood cuttings

Among the many Philadelphus growing at Winterthur are:

P. x *virginalis* 'Minnesota Snowflake'

· Minnesota snowflake mock orange

ORIGIN
Complex parentage

ABOUT
White, double flowers. Hardy to –30°F.

SIZE
6 – 8′ tall
5 – 6′ spread

SUN
Sun to light shade
Zones (3) 4–8

P. x *virginalis* 'Virginal'

· Virginal mock orange

ORIGIN
Complex parentage

ABOUT
White, semi-double flowers; fragrant.

SIZE
9′ tall
7′ spread

SUN
Sun to light shade
Zones 5–8

Spiraea x *margaritae*

· Margarita spirea
· Rosaceae

ORIGIN
Asia and the U.S.

ABOUT
Deciduous, mounded shrub. Clusters of deep pink flowers in early summer. Trouble free. Prune after flowering.

SIZE
4′ tall
Equal spread

SOIL
Any good garden

PROPAGATION
Softwood or hardwood cuttings

SUN
Sun
Zones 4–8

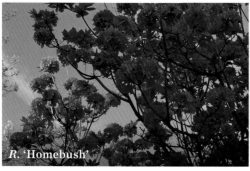

R. 'Homebush'

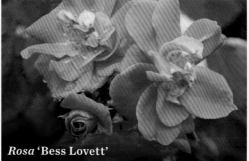

Rosa 'Bess Lovett'

Rhododendron

· Azalea
· Ericaceae

SOIL
Acid, moist, well
drained, organic

SUN
Partial shade

R. 'Martha Hitchcock'

· Martha Hitchcock
 azalea

ORIGIN
Parents from Asia

ABOUT
Evergreen. White
flowers with lavender
edge in late spring.
A Glenn Dale azalea;
bred for large flowers
and hardiness in the
Mid-Atlantic.

SIZE
4′ tall
equal spread

SUN
Partial shade
Zones 6–9

R. 'Homebush'

· Homebush azalea

ORIGIN
Complex parentage
(Knap Hill hybrid)

ABOUT
Deciduous. Bright
pink, semi-double
flowers in late spring.

SIZE
6 – 8′ tall, equal spread

SUN
Partial shade
Zones 5–8

R. 'Pallas'

· Pallas azalea

ORIGIN
Complex parentage
(Ghent hybrid)

ABOUT
Deciduous. Coral,
funnel-form flowers
in late spring.

SIZE
6 – 10′ tall
Equal spread

SUN
Partial shade
Zones 5–8

Rosa

· Rose

· Rosaceae

ORIGIN
Extensive hybridization and seedling selection
have resulted in complex heritage

ABOUT
Prune in early spring.

PROPAGATION
Softwood cuttings

SOIL
Well drained, high
organic content

SUN
Sun

Grouped here are two dependable cultivars:

R. 'Bess Lovett'

· Bess Lovett rose

ABOUT
Wichuraiana hybrid.
Deep pink, single
blossoms. Disease
resistant.

SIZE
5 – 10′ tall (climber)

SUN
Zones (3) 4–8

R. 'Pink Leda'

· Pink Leda rose

ABOUT
Damask hybrid.
Double, pink blossoms
in June. Compact.

SIZE
3′ tall
Equal spread

SUN
Zones 4–9

Weigela 'Eva Rathke'

· Eva Rathke weigela
· Caprifoliaceae

ORIGIN
Parents: Asia

ABOUT
Compact, deciduous
shrub. Deep wine red
flowers in late May.
Trouble free. 'Red
Prince' is similar in
color. Prune after
flowering.

SIZE
5′ tall
Equal spread

SOIL
Any good garden;
not dry

PROPAGATION
Softwood cuttings

SUN
Sun
Zones 5–8 (9)

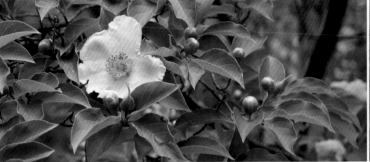

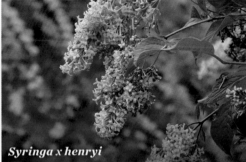

Syringa x henryi

Stewartia

· Stewartia
· Theaceae

ABOUT
Beautiful flowers, foliage, and habit distinguish stewartias. Three modest-size deciduous trees are grouped here. Trouble free.

SOIL
Acid, moist, well drained, organically rich

S. ovata

· Mountain stewartia

ORIGIN
North Carolina, Tennessee, Florida

ABOUT
Small tree or shrub; white, cupped, crepe-paper flowers in summer.

SIZE
10 – 15' tall
Equal spread

PROPAGATION
Propagation difficult, seed, softwood cuttings

SUN
Partial shade
Zones 5–8

S. pseudocamellia

· Japanese stewartia

ORIGIN
Japan, Korea

ABOUT
Small tree. White, cup-shape flowers in early summer. Beautiful round buds, leaves. Exfoliating bark. Excellent fall color. Cultivars available.

SIZE
20 – 40' tall
Equal spread

PROPAGATION
June cuttings

SUN
Partial shade
Zones (4) 5–7

S. rostrata

· Beaked stewartia

ORIGIN
China

ABOUT
Small tree or shrub; white, cupped flower with red bracts in early summer.

SIZE
15' tall

PROPAGATION
Seed, softwood cuttings

SUN
Zones 6–8

Syringa

· Lilac
· Oleaceae

ABOUT
Prune after flowering.

SOIL
Neutral, pH adaptable, well drained

PROPAGATION
Softwood cuttings

SUN
Sun

S. x henryi

· Henry's lilac

ORIGIN
Parents from China and Hungary

ABOUT
Large, spreading shrub. Lavender flowers. Valuable as a late bloomer. Cold hardy.

SIZE
10' tall
Equal spread

SUN
Zones 2–7 (8)

S. meyeri

· Meyer lilac

ORIGIN
China

ABOUT
Rounded shrub. Lavender flowers. Excellent bloomer. Modest size. Mildew resistant.

SIZE
4 – 8' tall
6 – 12' spread

SUN
Zones 3–7

S. reticulata

· Japanese tree lilac

ORIGIN
Japan

ABOUT
Creamy white flowers appear in June on this small tree. Relatively trouble free. Many cultivars.

SIZE
20 – 30' tall
15 – 25' spread

SUN
Zones 3–7

SUMMER

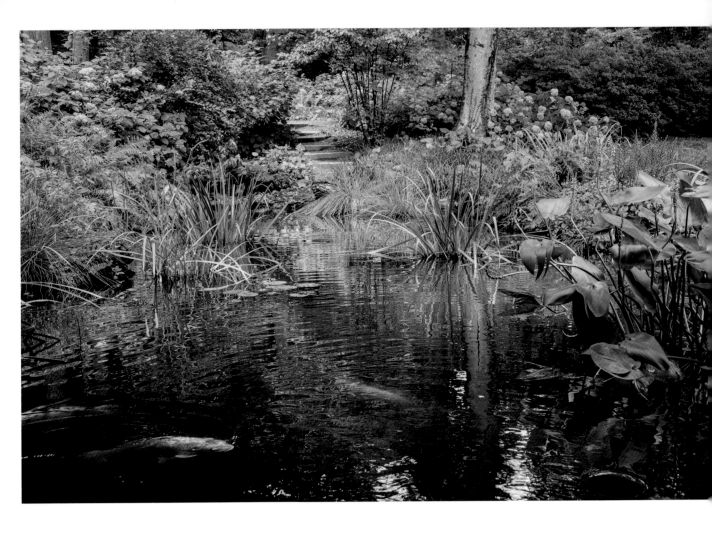

THE SUMMER WOODLAND BRINGS A RICH ARRAY OF GREEN FOLIAGE THAT helps cool the garden and adds to the color palette. Water also provides a calm, cooling effect. Described here are two areas in the garden using water in different styles. The Glade Garden is naturalistic and shady; the Reflecting Pool is formal, architectural, and sun drenched. We then look at a collection of summer-flowering shrubs and trees that add enjoyment to a summer garden.

GLADE GARDEN

June to July

The word *glade* calls to mind a shady
retreat, and the Glade Garden indeed
offers a peaceful and refreshing respite
from summer heat. This woodland
area features a waterfall that flows
into pools with bright orange, gold, and
white koi. A stone walkway bridges the
two pools and creates an ideal viewing
platform. The green foliage of various
ferns, shrubs, and trees sets off the
creamy white, orange, and purple of
the summer-flowering plants
around the pools. Smooth hydrangea
(*Hydrangea arborescens*) in both the
lace-cap and mophead blooms on new
growth, so fresh white flowers appear
through the summer as the older ones
fade to a lovely chartreuse. Graceful
orange daylilies (*Hemerocallis fulva*)
have naturalized around the lower pool.
Their color and form create a pleasing
contrast with the soft green foliage of
the silvery glade fern. Hostas (*Hosta
ventricosa*) add a royal touch with rich
purple flowers in late June and early
July. 🌱

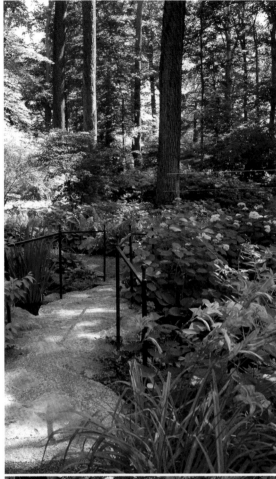

*Hydrangeas bloom
with daylilies alongside
ferns on the walkway
between the pools.*

*Hosta ventricosa in
early July on the
March Bank.*

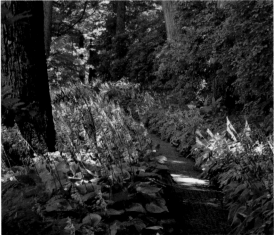

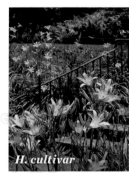

H. cultivar

In Your Garden

Although competing on the market with more colorful foliage, *Hosta ventricosa* has robust purple flowers to commend it. You will find this easy-to-grow plant throughout the Winterthur garden, notably on the March Bank. Its summer foliage contrasts well with ferns, and both can fill the spaces left open by spring bulbs and wildflowers.

Hemerocallis fulva

· Orange daylily
· Hemerocallidaceae

ORIGIN
Europe and Asia

ABOUT
Herbaceous perennial; blade-like leaves. Orange trumpet-shape flowers. Now naturalized/invasive in the eastern U.S. Recommended to use clump-forming cultivars that come in a wide range of colors.

SIZE
2 – 3' tall
Equal spread

SOIL
Adaptable

PROPAGATION
Division

SUN
Sun to partial shade
Zones (2) 3–9

Hosta ventricosa

· Blue hosta
· Asparagaceae

ORIGIN
Japan, Siberia

ABOUT
Herbaceous plant; forms clumps of handsome, large green leaves. In midsummer, rich purple flowers open on tall spikes.

SIZE
3' tall
Equal spread

SOIL
Moist, well-drained, high organic content

PROPAGATION
Division in early spring

SUN
Shade to partial shade
Zones 3–9

Hydrangea arborescens

· Smooth hydrangea
· Hydrangeaceae

ORIGIN
New York to Florida

ABOUT
Deciduous, shrub. Clusters of flowers turn from green to creamy white in summer. Hydrangeas are divided into lace-cap types (ring of large, sterile flowers surrounding a center of smaller fertile flowers) and hortensias or mopheads (large, sterile flowers that form a ball). Many cultivars of both types available. Trouble free. Often dried for flower arrangements. Prune in spring.

SIZE
3 – 5' tall, equal spread

SOIL
pH adaptable; likes rich, moist, well drained

PROPAGATION
Softwood cuttings

SUN
Partial shade to shade; sun, if sufficient moisture is available
Zones 3–9

H. arborescens 'Grandiflora'

· Hills of snow hydrangea

ABOUT
Rounded clusters of large, sterile flowers.

REFLECTING POOL & LOWER COURTYARD

May to October

The architecture of the Reflecting Pool area, of Italian Renaissance influence, presents superbly proportioned stairways, walls, and archways and affords a marvelous setting for the plants that grow here. A well-planned combination, with something almost always in flower, gives changing prospects throughout the year and provides ideas for our own gardens.

In the springtime, favorite azaleas and dogwoods are lush and colorful in pink, white, and lavender. Tree peonies flower in pale pink while soft pink *Clematis montana* var. *rubens* clambers over an ironwork arch. In the summer this area takes on an entirely new look. Bright annuals and perennials fill decorative containers, and tropical cannas and elephant ears flourish in the pool. In August and September, two permanent herbaceous plants bloom here. Hardy begonia (*Begonia grandis*) nestles into corners of gray stonework—a pleasing background for its pink pouch-like buds, flat blossoms, and handsome foliage. Growing in large

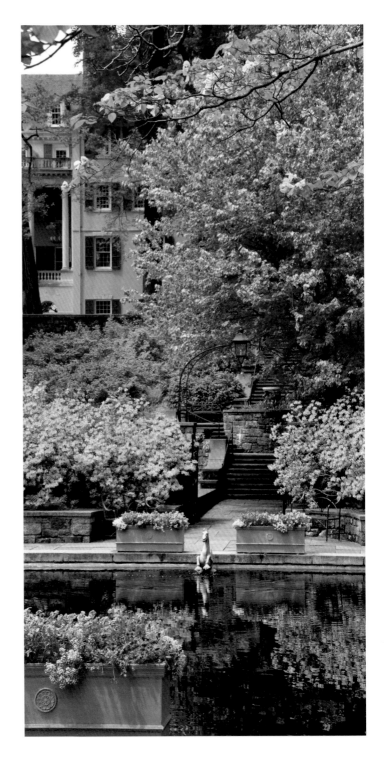

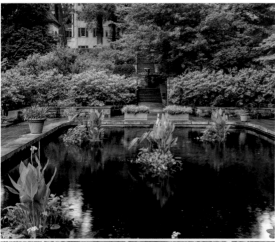

Reflecting Pool in August with Canna glauca and Colocasia antiquorum.

White crape myrtle (Lagerstroemia 'Natchez').

numbers is that most practical of ground covers, lily-turf (*Liriope muscari*), with purple gumdrop-like blossoms.

Lower Courtyard

From summer into fall, the courtyard and walkway beside the pool showcase pink, lavender, and white flowers. Outstanding among the shrubs is mountain hydrangea (*Hydrangea serrata* 'Shirofuji'), with delicate, double snowflake-like white blossoms from July through September. Bigleaf hydrangea, (*Hydrangea macrophylla* 'Lanarth White') is a lace-cap type with a ring of white sterile florets surrounding small blue or pink fertile flowers in the center. White crape myrtle (*Lagerstroemia* 'Natchez') grows companionably on either side of the hydrangeas.

In August summer sweet clethra (*Clethra alnifolia*) produces fragrant white spires and is followed by white hosta (*Hosta* 'Royal Standard'). In September *Hydrangea paniculata* 'Tardiva' opens white panicles that gradually turn rosy pink, a color that is picked up by the glossy abelia (*Abelia* x *grandiflora*), which produces soft pink flowers and long-lasting rosy sepals from July until frost. Under all, lavender rose astilbe (*Astilbe chinensis* var. *pumila*) flowers for many weeks. ⚘

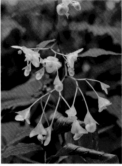

In Your Garden

This simple palette of white and pink summer-flowering perennials, shrubs, and trees brightens the lower courtyard and walkway. The hydrangeas, crape myrtles, abelias, and astilbes catch the colors from spring and take them into autumn. The area was redesigned in 1992 to create an entertainment space that would fit the design aesthetic of the garden. The staff specifically wanted to emulate a design practice of Mr. du Pont's of repeating the same color combinations in other seasons and extending the season of color. The lighter colors, especially the white flowers, show well in the fading light. In selecting your plants and their placement, consider what time of the year and time of the day you will most often be able to enjoy the garden.

Abelia x grandiflora

· Glossy abelia
· Caprifoliaceae

ORIGIN
Parents: China

ABOUT
Semi-evergreen, spreading shrub. White-tinged-pink, funnel-form flowers; long-lasting rosy sepals. Trouble free. Prune in spring. Cultivar available.

SIZE
3 – 6′ tall
Equal spread

SOIL
Acid, moist, well drained

PROPAGATION
Softwood cuttings

SUN
Sun to partial shade
Zones (5) 6–9

Astilbe chinensis var. pumila

· Dwarf Chinese astilbe
· Saxifragaceae

ORIGIN
China

ABOUT
Herbaceous perennial. Fuzzy, lavender rose, upright panicles bloom in midsummer.

SIZE
12 – 18″ tall
Equal spread

SOIL
Moist, well drained, organically rich

PROPAGATION
Division

SUN
Partial shade to shade
Zones 4–8

Begonia grandis

· Hardy begonia
· Begoniaceae

ORIGIN
Asia

ABOUT
Herbaceous perennial. Large, green, heart-shape leaves. Soft pink, pouchlike buds; flat flowers in late summer.

SIZE
2 – 3′ tall
Equal spread

SOIL
Moist, well drained, organically rich

PROPAGATION
Bulblets, seed

SUN
Partial shade to shade, foliage will scorch in sun
Zones 6–9

'Alba'

ABOUT
White flower cultivar.

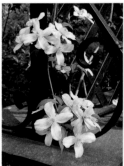 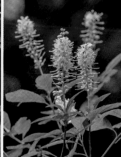 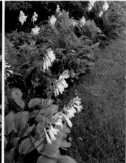

Clematis montana var. *rubens*

- Pink anemone clematis
- Ranunculaceae

ORIGIN
China

ABOUT
Deciduous vine. Soft pink flowers in spring. Prune after flowering.

SIZE
20' tall

SOIL
Fertile, well drained

PROPAGATION
Softwood cuttings

SUN
Sun, shade for roots
Zones 5–8

Clethra alnifolia

- Summer sweet clethra
- Clethraceae

ORIGIN
Eastern U.S.

ABOUT
Deciduous shrub. Fragrant, white, upright panicles of flowers in late summer. Good yellow fall color. Easy. Cultivars available, some pink.

SIZE
4–8' tall

SOIL
Moist, acid

PROPAGATION
Softwood cuttings, division, seed

SUN
Sun to partial shade
Zones 4–8

Hosta 'Royal Standard'

- Royal standard hosta
- Asparagaceae

ORIGIN
Parentage complex

ABOUT
Herbaceous plant. Handsome, large leaves form clumps. Fragrant, white, lily-like flowers on tall spikes in late summer.

SIZE
2–3' tall
Equal spread

SOIL
Rich, well drained, consistently moist

PROPAGATION
Division in early spring

SUN
Partial shade to shade
Zones 3–9

Liriope muscari

- Blue lily-turf
- Asparagaceae

ORIGIN
Asia

ABOUT
Practical ground cover with clumps of strap-like, evergreen foliage. Lavender flowers on upright stalks in late summer. Withstands heat, drought. Few diseases or pests. Cut back in early spring. Many cultivars.

SIZE
12–18" tall
12" spread

SOIL
Adaptable

PROPAGATION
Division, seeds

SUN
Sun to shade
Zones 6–9

Lagerstroemia indica x *L. fauriei* 'Natchez'

- Natchez crape myrtle
- Lythraceae

ORIGIN
Parent species from China, Japan, Korea

ABOUT
Deciduous upright shrub or tree. White flowers in summer. Cinnamon-color bark. Good fall color.

SIZE
20' tall
Equal spread

SUN
Sun
Zones (6) 7–9

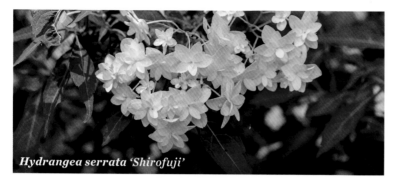
Hydrangea serrata 'Shirofuji'

Hydrangea
Species and Cultivars

· Hydrangeaceae

ORIGIN
China, Japan, Korea

ABOUT
Hydrangeas described below are deciduous and
flower in summer and early fall. Trouble free.

SOIL
Moist, well drained

PROPAGATION
Softwood cuttings

H. macrophylla
'Lanarth White'

· Bigleaf hydrangea

ABOUT
White flowering
lace-cap form with
small blue or pink
sterile flowers in
the center, flowers
on old wood.

SIZE
3 – 5' tall
Equal spread

SUN
Partial sun
Zones 6–9

H. paniculata
'Tardiva'

· Panicle hydrangea

ABOUT
Has an attractive
mixture of sterile
(conspicuous)
and fertile
(inconspicuous)
white flowers. Late
blooming. Flowers
on new wood.

SIZE
8 – 12' tall
7 – 10' spread

SUN
Sun to part shade
Zones 3–8

H. serrata
'Shirofuji'

· Mountain hydrangea

ABOUT
White lace-cap flowers
on old wood.

SIZE
2' tall
Equal spread

SUN
Partial sun
Zones: 6–9

PLANTS FOR SUMMER FLOWER

July to October

Several favorite flowering shrubs and trees brighten our summer gardens. There are some late bloomers among them, many with the desirable trait of a long flowering period. For this reason and because these plants are relatively few in number, each one is noteworthy.

Enchanted Woods

Enchanted Woods is a marvelous addition to the Winterthur garden, combining materials from across the estate. To blend the Winterthur gardening style with this area, plants and color choices used in other parts of the garden are repeated here. Hydrangeas with blue, lavender, pink, rose, and white flowers color this area throughout the summer. Native hydrangeas, smooth (*H. arborescens*) and oakleaf (*H. quercifolia*), begin the display in June with white blossoms. Using lace-cap and mophead forms of the smooth hydrangea provides the added bonus of creating textural interest and color through the summer and fall. The white flowers of oakleaf hydrangea also persist and age to a chartreuse or dusty rose depending on the cultivar.

Non-native hydrangeas expand the range of colors available. Of special note are Preziosa (*H.* 'Preziosa'), a soft lavender hortensia (ball type or mophead) that turns pink and then deep mauve rose, and Blue Wave hydrangea (*H. macrophylla* 'Mariesii Perfecta') with soft blue lace-cap flowers. Flowering later in summer is Sargent's hydrangea (*H. aspera* v. *sargentiana*) and bracted hydrangea (*H. involucrata*). Both offer exquisite blue and white lace-cap flowers and soft fuzzy leaves.

Native and non-native clethras also brighten and perfume the summer air in Enchanted Woods. A dwarf form of the summer sweet clethra (*Clethra alnifolia* 'Hummingbird') produces its fragrant white flowers in midsummer. Japanese clethra (*Clethra barbinervis*) offers sprays of white flowers in late summer. You can train it as a large shrub or as a small tree to highlight its exfoliating bark.

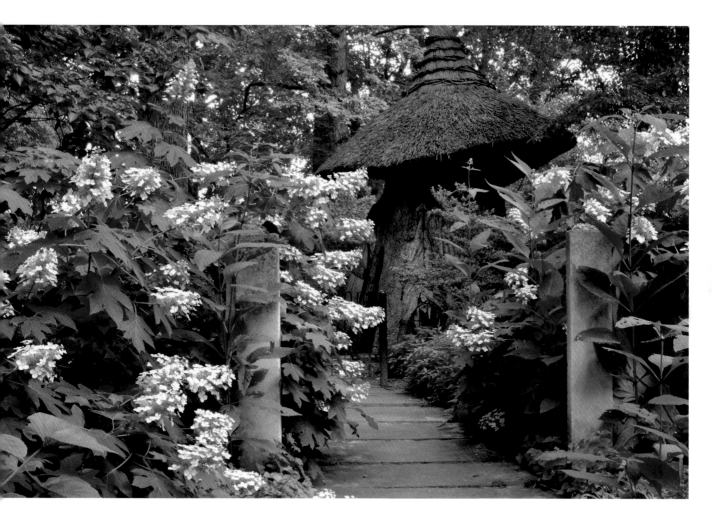

Summer-Flowering Shrubs

Other July-flowering shrubs that make nice additions to sunnier gardens are chaste-trees (*Vitex agnus-castus* species and cultivars) in lavender, pink, and white as well as *Hibiscus syriacus* 'Bluebird.' Panicle hydrangeas (*Hydrangea paniculata*) flower later, producing large, white, cone-shape inflorescences that gradually turn rosy and blend well with a clear pink crape myrtle (*Lagerstroemia* x 'Biloxi'). There are now cultivars of the panicle hydrangea with flowers that start and stay a bright rosy color. Crape myrtles are also available in a wider range of options with white, pink, red or purple

Hydrangea quercifolia, oakleaf hydrangea frames the path to the Tulip Tree House.

(top) Hydrangea 'Preziosa' circles the Gathering Green, beside the Faerie Cottage.

(bottom) Crape myrtle provides summer color and attractive bark.

flowers with a mix of bark colors and different sizes. A dark pink crape myrtle (*Lagerstroemia* x 'Sioux') adds summer interest to the museum entrance.

Summer-Flowering Trees

Yellowwood (*Cladrastis kentukea*) is a handsome native tree that would be a fine addition to almost any open space. Rounded in form with lively green foliage, in June this tree has pendulous, white, fragrant blossoms. Another native of smaller stature is sourwood (*Oxydendrum arboreum*), which grows in Enchanted Woods and on the museum lawn. In June and July this tree bears exquisite, small lily-of-the-valley-like flowers. Its graceful foliage turns red in the fall.

In July goldenrain trees (*Koelreuteria paniculata*) flower in attractive, yellow upright sprays. Looking more like sunshine than rain, the blossoms are followed by light greenish seedpods that last a long time and may be responsible for its common name. The color of the seedpods relates nicely to the creamy blossoms of sophora (*Sophora japonica*) or the Japanese pagoda tree that appears nearby. With a rounded crown at maturity, the sophora is noted for giving the soft, dappled shade often desired near a house; it also tolerates urban conditions. 🌱

In Your Garden

Hydrangeas offer many choices for the home gardener, and hybridizers continue to expand the range of options in colors, size, cold hardiness, and re-bloom. Their flowers are summer classics, but they have other attributes. The dried flowers of many of hydrangeas tend to persist through the winter and thus provide textural interest. Oakleaf hydrangea has deep-red fall foliage and peeling bark for winter interest. A climbing form, *H. petiolaris,* can add height to your flower display either growing on structures or trees. Sun or shade, there is a hydrangea that will do well for you.

Preziosa hydrangea turns pink, then deep mauvy rose; here it blooms beside blue and pink lace-cap hydrangeas.

Cladrastis kentukea

· American
 Yellowwood
· Fabaceae

ORIGIN
Eastern U.S.

ABOUT
Deciduous tree.
Rounded crown;
graceful, white,
pendulous flowers
in early summer.
Trouble free. Prune
only in summer to
avoid bleeding.

SIZE
30 – 50′ tall
40 – 55′ spread

SOIL
Adaptable,
well drained

PROPAGATION
December cuttings

SUN
Sun
Zones 4–8

Clethra alnifolia 'Hummingbird'

· Summer sweet clethra
· Clethraceae

ORIGIN
Eastern U.S. for species

ABOUT
Deciduous shrub.
Fragrant white,
upright panicles
of flowers in late
summer. Good
yellow fall color.
Easy.

SIZE
3 – 4′ tall, more
compact than species

SOIL
Moist, acid

SUN
Sun to partial shade
Zones 4–8

Clethra barbinervis

· Japanese clethra
· Clethraceae

ORIGIN
China, Japan

ABOUT
Deciduous shrub.
Fragrant, white,
drooping panicles
of flowers in late
summer. Good
yellow fall color.
Easy.

SIZE
10 – 20′ tall
10 – 15′ spread

SOIL
Moist, slightly acidic

PROPAGATION
Seed, summer cuttings

SUN
Sun to partial shade
Zones 5–8

 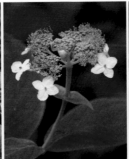 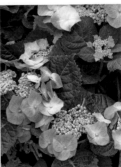

Hibiscus syriacus

· Rose of Sharon
· Malvaceae

ORIGIN
China, India

ABOUT
Deciduous shrubs.
Bloom in summer.
Many cultivars, from
white to pink, red,
lavender, purple.
Prune in spring.

SIZE
8 – 12′ tall
6 – 10′ spread

SOIL
Adaptable, but prefers
moist, well drained

PROPAGATION
Softwood cuttings

SUN
Sun to partial shade
Zones 5–8 (9)

H. syriacus 'Bluebird'

ABOUT
Lavender blue

Hydrangea **Species and Cultivars**

· Hydrangeaceae

ABOUT
Hydrangeas described below are deciduous
shrubs and bloom in summer and early fall.
Trouble free. Numerous cultivars available
for each species.

SOIL
Moist, well drained

PROPAGATION
Softwood cuttings

H. arborescens

*For detailed
information, see
"Glade Garden."*

Hydrangea aspera **subsp. sargentiana**

· Sargent's hydrangea

ORIGIN
China

ABOUT
White and blue
lace-cap flowers,
velvety leaves.

SIZE
3 – 6′″ tall
Equal spread

SUN
Partial shade
Zones 6–9

Hydrangea involucrata

· Bracted hydrangea

ORIGIN
Japan, Taiwan

ABOUT
White sterile flowers
with small blue or
pink fertile flowers
in the center.

SIZE
5′ tall
Equal spread

SUN
Partial shade
Zone 6

Hydrangea macrophylla

· Bigleaf hydrangea

ORIGIN
Japan, Korea

'Mariesii Perfecta'

· Blue Wave hydrangea

ABOUT
Blue lace-cap type.
If necessary, acidify
soil with aluminum
sulfate since blueness
in hydrangeas depends
on availability of
aluminum ions.
Prune after flowering.

SIZE
3 – 6′ tall
Equal spread

SUN
Sun to partial shade
Zones 5–9

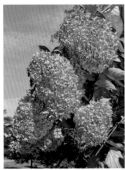 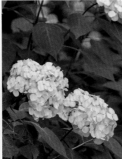 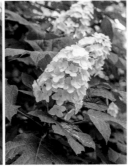 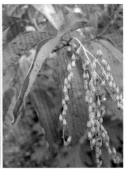

Hydrangea paniculata

· Panicle hydrangea

ORIGIN
Japan, China

ABOUT
White, then rose, flowers in late summer and early fall. Mixture of showy, sterile flowers and inconspicuous, fertile flowers. Prune in winter. Some cultivars are pink.

SIZE
10 – 20′ tall
Equal spread

SOIL
Moist, rich

SUN
Sun to partial shade
Zones 3–8

H. paniculata 'Grandiflora'

· Pee Gee hydrangea

ABOUT
A cultivar with more sterile (conspicuous) flowers in clusters, causing stems to arch. Prune in winter.

Hydrangea 'Preziosa'

· Preziosa hydrangea

ORIGIN
Parentage uncertain

ABOUT
Lavender hortensia, turns pink then mauve rose. Prune after flowering.

SIZE
4′ tall
Equal spread

SOIL
Moist, well drained, acid or neutral

SUN
Sun to partial shade
Zones (5) 6–7

Hydrangea quercifolia

· Oakleaf hydrangea

ORIGIN
Southeastern U.S.

ABOUT
Upright panicles of white flowers in June, exceptional red fall foliage. Prune after flowering.

SIZE
6 – 8′ tall
Equal spread

SOIL
Moist, well drained

SUN
Sun to partial shade
Zones 5–9

Koelreuteria paniculata

· Goldenrain tree
· Sapindaceae

ORIGIN
China, Japan, Korea

ABOUT
Deciduous, rounded tree. Upright sprays of yellow flowers in midsummer. Showy, light greenish fruits follow. Prune during winter.

SIZE
30 – 40′ tall
Equal spread

SOIL
Adaptable

PROPAGATION
Hardwood cuttings. It will self-sow readily, perhaps best used in lawns for this reason.

SUN
Sun
Zones (4) 5–8

Oxydendrum arboreum

· Sourwood
· Ericaceae

ORIGIN
Eastern and southeastern U.S.

ABOUT
Deciduous tree. White lily-of-the-valley type flowers. Excellent red fall leaf color.

SIZE
20 – 50′ tall
10 – 25′ spread

SOIL
Acidic, moist, well drained

PROPAGATION
Seeds, softwood cuttings

SUN
Sun to partial shade
Zones 5–9

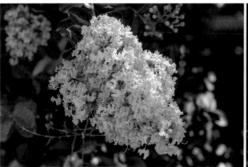

Lagerstroemia indica x *L. fauriei* hybrids

· Crape myrtle
· Lythraceae

ORIGIN
Parent species from China, Korea, Japan

ABOUT
Upright, deciduous shrub or tree. Summer bloom of cone-shape panicles on arching branches. Species and cultivar flower colors range from white, pink, purple, and red. Cultivars in various heights and bark color. Prune in spring or immediately after flowering.

SIZE
8 – 25′ tall, equal spread

SOIL
Moist, well drained

PROPAGATION
Seed, softwood cuttings

SUN
Sun
Zones (6) 7–9

L. x 'Biloxi' and *L.* x 'Sioux'

· Crape myrtle cultivars

ABOUT
Pink

SIZE
15 – 25′ tall, 15′ spread

SUN
Zones 7–9

Sophora japonica

· *Styphnolobium japonicum*
· Japanese pagoda tree
· Fabaceae

ORIGIN
China, Korea

ABOUT
Deciduous, round-head tree. Clusters of hanging, creamy flowers in late summer.
Trouble free.

SIZE
50 – 70′ tall
Equal spread

SOIL
Well drained, adaptable

PROPAGATION
Softwood cuttings

SUN
Sun
Zones 4–7

Vitex agnus-castus

· Chaste-tree
· Lamiaceae

ORIGIN
Europe and Asia

ABOUT
Deciduous shrub; spreading habit. Palmate leaves, panicles of lavender flowers in midsummer. Trouble free. Prune early spring. Many cultivars, including deeper lavender, pink, and white forms.

SIZE
8 – 10′ tall
Equal spread

SOIL
Moist, well drained, neutral

PROPAGATION
Softwood cuttings

SUN
Sun
Zones (6) 7–8 (9)

Perennials of Summer & Fall

Berries & Blossoms

Fall Foliage

SUMMER *into* FALL

TEMPERATURES COOL AS FALL APPROACHES, BUT VIBRANT COLORS
create stunning views and vistas in the garden. What we planted in the spring has an
entirely different look in this season, and the ever-changing landscape is a delight
to gardeners. Fall brings berries in abundance, adding texture and color, as do fall-
flowering perennials and bulbs. Explore the rich mix of summer-into-fall enchantment
at Winterthur.

PERENNIALS OF SUMMER & FALL

August to October

The late summer garden can sometimes begin to look a little tired, but a number of perennials are just coming into flower to enliven the woodlands and meadows. Several of our native asters and goldenrods are flowering in the shady areas of the garden as well as in the sunny meadows. Following Mr. du Pont's goal of adding summer color, we have encouraged these natives and introduced new perennials, using them in his design style of large naturalistic plantings.

Hairy alum root (*Heuchera villosa*) has proven to be an outstanding native perennial for the dry shady areas of the garden. It bears small, creamy white flowers on two-foot spikes, creating a bottlebrush effect. The flowers appear in August and persist through autumn. The large, chartreuse foliage provides color and textural interest through most of the year. Purple leaf forms are also available.

Hardy begonia (*Begonia grandis*) also does best in shade and can be found around the Reflecting Pool and in Enchanted Woods. The pink flowers begin to show in July, but the main display is in August and September. The paler seed capsules will continue to add color until frost. A white flowering form, *Begonia grandis* 'Alba,' combines well in September with the white fairy wands of Japanese bugbane (*Actaea japonica*) and the native white wood aster (*Eurybia divaricata*), which is a valuable fall-flowering plant. This species is quite undemanding and grows in a number of situations. Its ray flowers (petals) give it the appearance of an asterisk or star beginning in August, at its height in September, and lingering into October. It can handle dry shade conditions and spreads rapidly. For October color, try the blue wood aster (*Symphyotrichum cordifolium*). It can tolerate shade but will flower more profusely in sun.

There are several species of goldenrods (*Solidago*) that can grow in a wide variety of conditions and provide a long flower season. Many of these are tall and sun loving and feature flowers in a plume-like top. The zigzag goldenrod (*Solidago flexicaulis*) is a shorter, approximately 2-feet-tall, shade-tolerant species. Its flowers appear in September in small cluster along the top portion of the erect stems. You

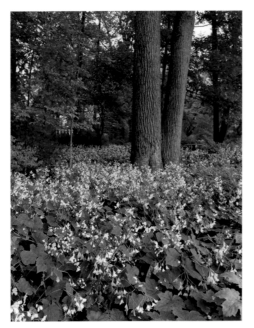

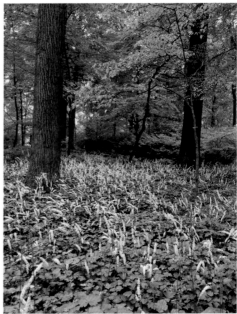

will want to site it where its spreading nature can work to your advantage. To extend the yellow color into the October woodland garden, use the wreath goldenrod (*Solidago caesia*). It flowers along its arching 2-foot stems and is less aggressive than the zigzag goldenrod. Growing in abundance in shade or sun is white snakeroot (*Ageratina altissima*), with fuzzy, white flowers in flat-top clusters, similar to annual ageratum. The plant is full and floriferous in October, when it lends charm to many areas of the estate. The flowers will last for weeks and will be more abundant in full sun.

A recent addition to Winterthur's woodland garden is toad-lily (*Tricyrtis* sp.), an exotic, orchid-like flower available in shades of purple, white, and yellow. The different species and cultivars of this deciduous perennial provide flowers from midsummer to November. The arching or upright stems average 2- to 3-feet tall. Toad-lilies combine well with ferns and hosta and offer an interesting textural contrast with their foliage. The purple flowers of *Hosta lancifolia* echo the purple of toad-lilies in late August to early September.

Fall-Flowering Bulbs

Three fall-flowering bulbs featuring chalice-like blossoms are noteworthy. First is showy colchicum (*Colchicum byzantinum*), sometimes called autumn crocus, though it is not a true crocus. On Oak Hill, colchicum is planted in the lawn, which is important for its effectiveness since the foliage comes in spring and dies down by midsummer. As a cut flower, colchicum will last in water for several days.

Another plant with a misleading common name is *Sternbergia lutea*. Known as fall daffodil, its rich yellow blossoms look more like crocuses than daffodils, yet it is neither. Perhaps it is best to use the Latin *Sternbergia* and honor the Austrian botanist for whom the plant is named. It features strap-shape foliage that accompanies the blossoms, which are attractive with the colors of autumn leaves. *Sternbergia* is also excellent with the berries of hardy orange, tea viburnum, and beautyberries with which it is grouped on Oak Hill. Showy crocus (*Crocus speciosus*), a third fall-blooming plant, really is what its common name implies: a crocus. Easy to grow, it has bluish lavender petals and bright orange divided stigmas. It flowers when the foliage is very short; after blooming, the foliage continues to elongate.

Tricyrtis 'Sinonome' combines well with ferns.

With adjustments to the mowing schedule, Colchicum byzantium can thrive in the lawn.

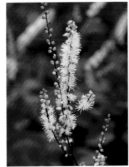
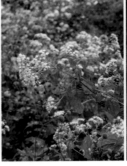
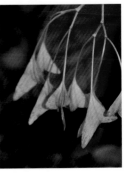

In Your Garden

Late summer and fall color displays in meadows, woodlands, and gardens can be highlights of the year. Consider using the whites, blues, purple, pinks, and yellows of these late-flowering perennials and bulbs to echo or complement the color of fall fruit and foliage or the lingering flowers of woody plants. For large areas, even those you consider problem areas, you might try some of the more vigorous plants that have prospered at Winterthur, such as white snakeroot and white wood aster. For a smaller garden or cultivated bed, wreath goldenrod, Japanese bugbane, and toad-lilies make fine additions. You will want to site your fall-flowering bulbs so that the foliage of other perennials does not hide their shorter flowers. This makes lawns an excellent location for them.

Actaea japonica

· Japanese bugbane
· Ranunculaceae

ORIGIN
Japan

ABOUT
Herbaceous perennial. Small white flowers clustered on 2′ spires in September.

SIZE
24 – 28″ tall
Equal spread

SOIL
Moist, well drained

PROPAGATION
Seed

SUN
Partial shade
Zones 3–7

Ageratina altissima

· *Eupatorium rugosum*
· White snakeroot
· Asteraceae

ORIGIN
Eastern North America

ABOUT
Herbaceous perennial. Clusters of fuzzy, white flowers in fall.

SIZE
3 – 5′ tall
4′ spread

SOIL
Moist, well drained

PROPAGATION
Spreads by rhizomes and self-seeding, may become invasive. Cut back after flowering to prevent seed development

SUN
Sun to light shade
Zones 3–7

Begonia grandis

· Hardy begonia

For detailed information, see "Reflecting Pool & Lower Courtyard," p. 101

 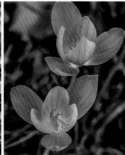 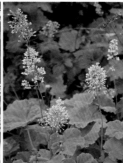 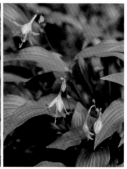

Colchicum byzantinum

· Showy colchicum
· Colchicaceae

ORIGIN
Turkey

ABOUT
Corm. Pinkish lavender, crocus-like flowers in early fall. Best displayed in beds with low foliage or in the lawn since the taller foliage of many perennials will obscure the blossoms. The spring-growing, wide foliage dies down in summer. Trouble free. Several species and cultivars available.

SIZE
4 – 6″ tall
Equal spread

SOIL
Rich, well drained

PROPAGATION
Seed or offsets

SUN
Partial shade
to full sun
Zones 5–7

Crocus speciosus

· Showy crocus
· Iridaceae

ORIGIN
Russia, Turkey

ABOUT
Corm. Lavender chalice-like flowers with conspicuous orange stigmas in mid-autumn. Blade-like leaves. Can be grown in grass. Several species and cultivars available.

SIZE
4 – 6″ tall
6″ spread

SOIL
Adaptable

PROPAGATION
Produces offsets, self-seeds

SUN
Sun
Zones (4) 5–7 (8)

Eurybia divaricata

· *Aster divaricatus*
· White wood aster
· Asteraceae

ORIGIN
Eastern North America

ABOUT
Herbaceous perennial. White daisy-type flowers in late summer and fall.

SIZE
1 – 2′ tall
Equal spread

SOIL
Moist to dry

PROPAGATION
Spreads by rhizomes and self-sows, can be aggressive

SUN
Sun to shade
Zones 3–8

Heuchera villosa

· Hairy alum root
· Saxifragaceae

ORIGIN
Eastern U.S.

ABOUT
Herbaceous perennial. Spikes of creamy white flowers brighten the shade in late summer and autumn. Easy.

SIZE
1½ – 3′ tall
1 – 2′ spread

SOIL
Moist to dry

PROPAGATION
Divisions

SUN
Partial to full shade, foliage will scorch in full sun
Zones 3–8

Hosta lancifolia

· Narrow-leaf hosta
· Asparagaceae

ORIGIN
Uncertain origin

ABOUT
Herbaceous perennial; narrow solid green leaves, purple flowers in late August to early September.

SIZE
12″ tall
12″ spread

SOIL
Moist to dry

SUN
Partial shade to shade
Zones 3–8

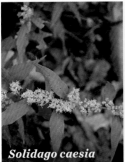

Solidago caesia

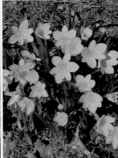

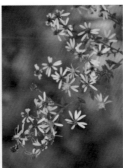

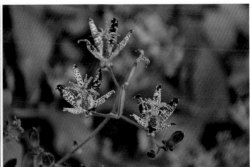

Solidago

· Goldenrod
· Asteraceae

ORIGIN
Eastern N. America

ABOUT
Herbaceous perennial.
Golden yellow flowers
along arching stems.

SIZE
1 – 3′ tall, 1 – 2′ spread

SOIL
Moist to dry

PROPAGATION
Seeds or division of
rhizomes in spring

SUN
Sun to partial shade
Zones 3–8 (9)

S. caesia

· Wreath goldenrod
ABOUT
Clump forming.
Flowers in October.

S. flexicaulis

· Zigzag goldenrod
ABOUT
Spreads readily by
rhizomes. Flowers in
September.

Sternbergia lutea

· Fall daffodil
· Amaryllidaceae

ORIGIN
Mediterranean region

ABOUT
Bulb. Rich yellow,
crocus-like flowers
and strap-like foliage
in fall. Needs hot,
baking sun in summer.
Trouble free.

SIZE
6 – 10″ tall
Equal spread

SOIL
Adaptable

PROPAGATION
Seed or offsets

SUN
Sun
Zones 6–9

Symphyotrichum cordifolium

· *Aster cordifolius*
· Blue wood aster
· Asteraceae

ORIGIN
Eastern and central
North America

ABOUT
Herbaceous perennial.
Lavender-blue daisy-
like flowers in October.

SIZE
2 – 5′ tall
1½ – 2′ spread

SOIL
Moist to dry

PROPAGATION
Self-sows

SUN
Sun to partial shade
Zones 3–8

Tricyrtis species and cultivars

· Toad-lily
· Liliaceae

ORIGIN
Himalayas to
eastern Asia

ABOUT
Herbaceous
perennial. Purple,
white, or yellow
flowers on arching
or erect stems in fall.
Easy.

SIZE
1 – 3′ tall

SOIL
Moist

PROPAGATION
Seeds or division

SUN
Part shade to shade
Zones 4–8

T. 'Sinonome'

ABOUT
A proven performer.
It is a readily available,
slow-spreading hybrid.
Heavy purple specking
on white flowers gives
the overall appearance
of being purple.

SIZE
2 – 3′ tall

T. hirta 'Miyazaki'

ABOUT
Hybrids will provide a
similar color but on a
slightly shorter plant.

SIZE
18″ tall

T. 'White Towers'

ABOUT
White flowering
hybrid.

SIZE
1 – 2½″ tall

BERRIES & BLOSSOMS

July to November

Berries

By mid-August, berries and fruit are noticeable everywhere. Part of nature's bounty, they add another dimension to gardens in early fall. Most berries attract birds; in fact, some berries are so appealing that they are rarely seen in their ripened state. Others last much of the winter. One of the most outstanding fruit displays is that of the kousa dogwood (*Cornus kousa*), the same tree that in June featured great "frosted" branches of blossoms. In late August and early September, the trees are laden with pendulous, rosy red fruit that resembles raspberries and is edible, though not very tasty. Our native dogwood (*C. florida*) produces shiny red berries in clusters of three or four during August and September.

Another small, flowering tree that produces red fruit is the Igiri tree (*Idesia polycarpa*). The hanging clusters of green berries of summer develop a rich orange-red color in September and hold well into December. The color shows well against the evergreens of our Pinetum. This tree is dioecious, so you will need a male and female plant for pollination and fruit development.

Other champion berry producers include the vast genus of viburnums. Among the earliest are the red berries of the doublefile viburnum (*V. plicatum* f. *tomentosum*), which appear in July, just in time to combine with *Hosta ventricosa* and other July-flowering plants. Also outstanding is smooth witherod (*V. nudum* 'Winterthur'), with berries that turn from green to white, then pink, and finally blue. Sometimes all colors appear at the same time in one cluster, vividly displayed against the glossy green leaves that change to a rich burgundy later in the fall.

Tea viburnum (*V. setigerum*) bears showy clusters of hanging oval fruit that turn orange-red in September. They will glow later in the fall against their maroon fall foliage. Yellow berries are rarer, but *V. dilatatum* 'Michael Dodge' has them in abundance. Linden viburnum, the species of which 'Michael Dodge' is a cultivar, has shiny

Red berries of Ilex verticillata 'Winter Red' with fall foliage of the American beech.

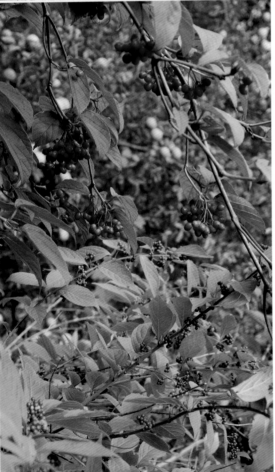

A classic color combination of H. F. du Pont is seen here with the purple fruit of Callicarpa japonica, red of Viburnum setigerum, and the yellow of Poncirus trifoliata.

red berries that last until late winter. Viburnums are invasive in parts of the United States. Check conditions for your area before selecting.

Our native deciduous hollies are an excellent alternative source of brilliant red, orange, or gold berries. Their fruit appears as early as September but really takes the stage when the leaves drop. A mass planting or an evergreen backdrop helps their fruit shine in the landscape. Hollies are dioecious so you will need to select male and female cultivars to ensure fruit production. One of the best for its abundant, bright red berries that last well into the winter is Winter Red winterberry (*Ilex verticillata* 'Winter Red'). Hybrid crosses between our native winterberry (*I. verticillata*) and Japanese winterberry (*I. serrata*) provide even more choices in fruit size and color as well as plant size and form. 'Sparkleberry' is a graceful hybrid covered with delicate red berries in fall.

Sapphireberry (*Symplocos paniculata*) is well named, featuring stunning blue berries that disappear about as fast as real sapphires would. In July, fragrant snowbell (*Styrax obassia*) produces pale green berries that look like bunches of grapes. Hardy orange (*Poncirus trifoliata*) develops golden fruit of golf-ball size. This thorny shrub makes an excellent barrier hedge.

Jewel-like violet berries that last from September through November are the most striking feature of beautyberries (*Callicarpa*) and are worth the wait. Purple beautyberry (*C. dichotoma*) is low and spreading, which makes it a good plant to use at the base of taller, leggier shrubs such as the tea viburnum. Purple beautyberry displays its berries along gracefully arching branches. Japanese beautyberry (*C. japonica*) is more vase shape and has clusters of berries in the same deep, royal violet tone. The name *Callicarpa* comes from two Greek words that mean "beautiful fruit."

Blossoms

A few late summer-flowering shrubs provide color well into autumn. This may be due to the continuation of flowering or the coloring of the bracts or sepals. Bracts are the colorful modified leaves just under, or mixed with, the fertile flowers, as in hydrangeas. One of the beauties of hydrangeas is that even the old flowers age well and add a special beauty to the fall and winter landscape. The dusty pink of the fading flowers of panicle hydrangea 'Tardiva' (*Hydrangea paniculata* 'Tardiva') and the oakleaf hydrangea (*Hydrangea quercifolia*) pair well with the rose-color sepals of the glossy abelia (*Abelia* x *grandiflora*).

Seven-son flower (*Heptacodium miconioides*) is a large shrub or small tree that echoes the white and rose of the hydrangea and abelia flowers. In September this tree is a cloud of thousands of small white flowers in clusters of seven, hence the name. It is a buffet for butterflies, bees, and other flying insects. As the flowers fade, the rose-color sepals become visible and create an even more vibrant and longer-lasting display through October. You can easily prune this plant into a shrub or tree depending on its role in your garden.

The common witch hazel (*Hamamelis virginiana*) is a bright yellow beacon in autumn with its brilliant fall foliage. Hidden among the leaves are small strap-like flowers. They persist after the foliage has dropped and offer a delicate, softer yellow glow. This handsome shrub reaches a height of 15 to 20 feet or more so you could train it as a small tree.

H. F. du Pont experimented with many fall-flowering camellias. These did not prove to be hardy, but today there are hardier forms available because of hybridization work with the sasanqua camellia (*Camellia sasanqua*) and the tea oil camellia (*C. oleifera*). These are available in shades of pinks and pure whites, single and double forms, and flower from October until killing

Fall scene with late pink from Hydrangea paniculata 'Tardiva' and Abelia x grandiflora.

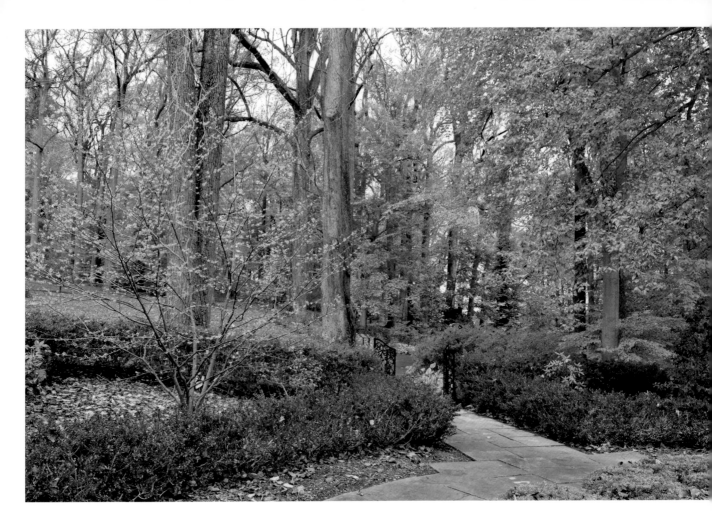

Hamamelis virginiana in flower in early November.

frost. The pink forms could work well with the rose-pink sepals and bracts of the hydrangeas, abelias, and seven-son flower. The names of the white, flowering cultivars attest to their flowering time and hardiness: 'Snow Flurry,' 'Survivor,' 'Winter's Snowman,' and 'Northern Exposure.' Growers in the Mid-Atlantic and northern areas recommend planting these evergreen shrubs in spring to give them more time to establish before their first winter. ⚜

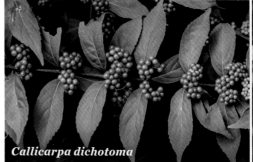
Callicarpa dichotoma

In Your Garden

It is easy to be carried away by a plant when it is in full bloom. To keep a garden interesting all year, however, we need two-, three-, or four-season plants. Dogwoods, *Cornus kousa* and *C. florida*, are wonderful in this regard, with their beautiful blossoms, fabulous fall foliage and fruit color, and winter architecture. Stewartias are similarly valuable. Shrubs such as glossy abelia, hydrangeas, and the seven-son flower offer a double season of color with their enduring flowers, bracts, and sepals.

**In this section, we have used the term* berry *loosely, since botanists differentiate fruits, naming them drupes, capsules, and pomes (among other designations), depending on their structure. Similarly, the term* bulb *here includes both bulbs and corms.*

Callicarpa

· Beautyberry
· Verbenaceae

ORIGIN
China, Japan

ABOUT
Deciduous shrub. Showy, violet fruit in fall. Pinkish lavender flowers, not showy. Can be cut back in spring; blooms on new wood.

SOIL
Well drained

PROPAGATION
Softwood cuttings

C. dichotoma

· Purple beautyberry

ORIGIN
China, Japan

ABOUT
Fruit along arching branches.

SIZE
3 – 4′ tall
Equal spread

SUN
Sun
Zones 5–8

C. japonica

· Japanese beautyberry

ORIGIN
Japan

ABOUT
Vase-shape shrub. Clusters of fruit.

SIZE
4 – 6′ tall
Equal spread

SUN
Sun to light shade
Zones 5–8

Hamamelis virginiana

· Common witch hazel
· Hamamelidaceae

ORIGIN
Eastern North America

ABOUT
Deciduous shrub. Fragrant, yellow, fringe-like blossoms appear with yellow fall foliage. Problem free, dependable. Prune after flowering.

SIZE
15 – 20′ tall
10 – 15′ spread

SOIL
Moist

PROPAGATION
Softwood cuttings

SUN
Sun or shade
Zones 3–8 (9)

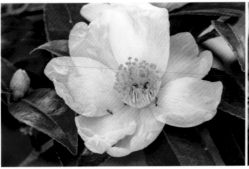
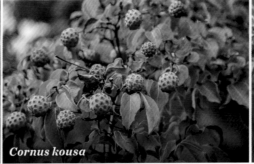

Cornus kousa

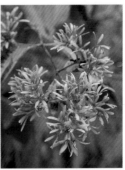

Camellia

· *oleifera* and *sasanqua* hybrids
· Camellia fall-flowering hybrids
· Theaceae

ORIGIN
Eastern and southern Asia

ABOUT
Evergreen shrub. Pink or white flowers in fall.

SIZE
4 – 10' tall, 4 – 10' spread

SOIL
Moist, well drained, slightly acid

PROPAGATION
Seeds, cuttings, layering

SUN
Sun to shade. Zones 6–9

Several cultivars are available.
The following have performed well at Winterthur:

'Northern Exposure' and 'Survivor'

ABOUT
Single white flowers.

'Winter's Snowman'

ABOUT
A semi-double with pink buds opening white.

'Snow Flurry'

ABOUT
Double white flowers.

Cornus

· Dogwood
· Cornaceae

SOIL
Acid, moist, well drained, organically rich

PROPAGATION
Softwood cuttings

SUN
Sun to partial shade

C. florida

· Flowering dogwood

ORIGIN
Eastern U.S.
and Mexico

ABOUT
In early spring, showy white bracts surround the true flowers. Beautiful horizontal branching. Clusters of shiny red berries in early fall; excellent fall foliage. Innumerable cultivars.

SIZE
20 – 40' tall
Equal spread

SUN
Sun to partial shade
Zones (5) 6–9

C. kousa

· Kousa dogwood

ORIGIN
Japan, Korea, China

ABOUT
Outstanding in late-spring bloom, when white flower bracts cover spreading branches. Raspberry-like fruit in early fall. Trouble free. Many cultivars.

SIZE
20 – 30' tall
Equal spread

SUN
Sun to partial shade
Zones 5–8

Heptacodium miconioides

· Seven-son flower
· Caprifoliaceae

ORIGIN
China

ABOUT
Deciduous shrub or small tree. White flowers in clusters of seven in September. Rose-color sepals (calyx) in October, ornamental bark.

SIZE
15 – 25' tall
12' spread

SOIL
Moist, well drained

PROPAGATION
Seeds, cuttings

SUN
Sun
Zones 5–9

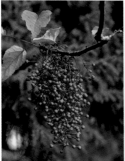
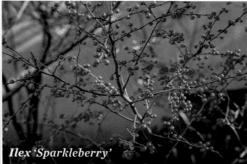

Ilex 'Sparkleberry'

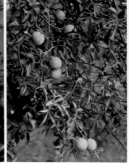
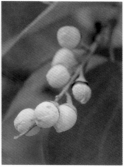

Idesia polycarpa

· Igiri tree
· Salicaceae

ORIGIN
Eastern Asia

ABOUT
Small, deciduous tree. Pendulous clusters of white flowers in early summer developing rich orange-red fruit in fall. Dioecious, needs a male and female plant.

SIZE
40 – 60′ tall
35 – 50′ spread

SOIL
Neutral to slightly acid, well drained

PROPAGATION
Seeds, cuttings, layering

SUN
Sun to part sun
Zones 4–8

Ilex verticillata

· Common winterberry
· Aquifoliaceae

ABOUT
Decidous shrub. Profuse red, orange, or yellow berries (female plant) in fall and winter. Requires male plant for pollination.

SIZE
3 – 12′ tall
3 – 12′ spread

SOIL
Moist, will tolerate wet, acid

SUN
Sun to partial shade
Zones 3–9

Ilex verticillata 'Winter Red'

ABOUT
Prized for its prolific, long lasting brilliant red berries

SIZE
6 – 8′ tall
Equal spread

Ilex 'Southern Gentleman'

ABOUT
Recommended as pollinator

ORIGIN
Eastern North America

Ilex 'Sparkleberry'

· Sparkleberry winterberry

ABOUT
Hybrid between *Ilex verticillata* and *Ilex serrata*. Deciduous shrub. Abundant but delicate red berries in fall.

SIZE
10 – 12′ tall
6 – 8′ spread

SOIL
Moist, acid

SUN
Sun to partial shade
Zones 5–9

Ilex 'Apollo'

ABOUT
Recommended as pollinator

Poncirus trifoliata

· Hardy orange
· Rutaceae

ORIGIN
China, Korea

ABOUT
Deciduous shrub. White, single flowers in mid-spring. Showy, golden yellow fruit ripens during fall. Sharp thorns. Trouble free.

SIZE
8 – 20′ tall
5 – 15′ spread

SOIL
Acid (though adaptable), well drained

PROPAGATION
Seeds, cuttings

SUN
Sun
Zones (5) 6–9

Styrax obassia

· Fragrant snowbell
· Styracaceae

ORIGIN
Japan, Korea

ABOUT
Deciduous tree. Flowers in graceful, white, hanging racemes in late spring. Pale green fruit by midsummer.

SIZE
20 – 30′ tall
15 – 25′ spread

SOIL
Acid, moist, well drained, high organic

PROPAGATION
Softwood cuttings in July

SUN
Sun to partial shade
Zones 5–8

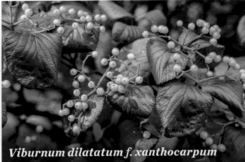

Viburnum dilatatum f. xanthocarpum

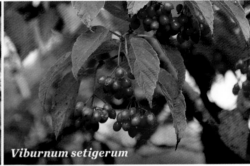

Viburnum setigerum

Symplocos paniculata

- Sapphireberry
- Symplocaceae

ORIGIN
Himalayas, China, Japan

ABOUT
Small deciduous tree. Fuzzy, creamy white, fragrant flowers in late spring. Brilliant blue fruit in early fall. Needs mate to ensure fruit set. Trouble free. Prune in winter if needed.

SIZE
10 – 20' tall
Equal spread

SOIL
Acid, well drained

PROPAGATION
Softwood cuttings

SUN
Sun to light shade
Zones 4–8

Viburnum

- Viburnum
- Adoxaceae

ABOUT
Upright, deciduous shrubs. Flowers bloom as creamy, flat clusters in late spring/early summer. Dependable, easy to grow.

PROPAGATION
Softwood cuttings

SUN
Sun to partial shade

V. setigerum

- Tea viburnum

ORIGIN
China

ABOUT
Orange-red fruit in clusters; decorative.

SIZE
8 – 12' tall
5 – 8' spread

SOIL
Moist, well drained, slightly acid

SUN
Zones 5–7 (8)

V. nudum 'Winterthur'

- Smooth witherod

ORIGIN
Species: Eastern U.S.

ABOUT
Lustrous green foliage turns rich burgundy in fall. Fruit changes from green to white, then pink, finally blue. Needs a species *V. nudum* or another cultivar for good berry set.

SIZE
6' tall
5' spread

SOIL
Acid, tolerates damp

SUN
Zones 5–9

V. dilatatum

- Linden viburnum

ORIGIN
Asia

ABOUT
Shiny red fruit lasts most of winter. More than one needed for good fruit set.

SIZE
8 – 10' tall
5 – 7' spread

SOIL
Moist, well drained, slightly acid

SUN
Zones (4) 5–7

V. dilatatum 'Michael Dodge'

- Michael Dodge viburnum

ABOUT
Yellow fruit

V. plicatum f. *tomentosum*

- Doublefile viburnum

ORIGIN
China

ABOUT
Large shrub. Maroon fall foliage. Showy red fruit turns black.

SIZE
8 – 15' tall
10 – 18' spread

SOIL
Moist, well drained, pH adaptable

SUN
Zones 5–8

V. dilatatum f. *xanthocarpum*

- Linden viburnum

ABOUT
Yellow fruit
.

FALL FOLIAGE

August to November

In autumn, nature combines all kinds of hues. Whole trees become tinted; big shrubs are saturated so that our surroundings are perhaps more colorful than at any other time of year. Although this panorama proceeds apace with no help from us, we can certainly give thought to including trees and shrubs with enjoyable fall color when planning our properties. One of the earliest signs of fall is provided by our native dogwood (*Cornus florida*), which takes on russet tones in September. Mixtures of red, green, yellow, and purple in the leaves, combined with red berries, give this handsome tree various effects depending on the sunlight. Meanwhile, Korean stewartia (*Stewartia koreana*), a rich red tree of splendid stature, has glorious color that lasts about six weeks. By mid-October, the woods are alive with the clear bright yellow of our native spicebush (*Lindera benzoin*), an open shrub that makes up in brilliance what it lacks in density. The viburnums mentioned earlier for their berry color also provide rich maroon or burgundy foliage.

Some shrubs have their best season in autumn. *Fothergilla*, for example, outdoes itself with vibrant shades of yellow, orange, and scarlet—often on the same plant, even on the same leaf. It colors late in the season, in late October and early November in the Sundial Garden. Two species, *F. major* and *F. gardenii*, offer a choice of sizes. A more unusual shrub, but equally outstanding for fall coloration, is white enkianthus (*Enkianthus perulatus*). Handsome year-round, with good habit and white, bell-like blossoms in spring, it is truly striking in autumn, when its leaves turn a brilliant red. It is not common in the trade but worth searching for. A related plant, redvein enkianthus (*Enkianthus campanulatus*), also has two special seasons. Spring brings white dangling, bell-shape flowers, while later in autumn the leaves turn lovely shades of apricot, red, yellow, and purple.

Several large native trees are exciting at this time of year as well. Red maple (*Acer rubrum*) and sugar maple (*A. saccharum*) are well known for their last hurrah of brilliant yellow, orange, and red. Our native sour gum (*Nyssa sylvatica*) offers red, orange, yellow, and purple tints early in the season. Also native and outstanding in the fall

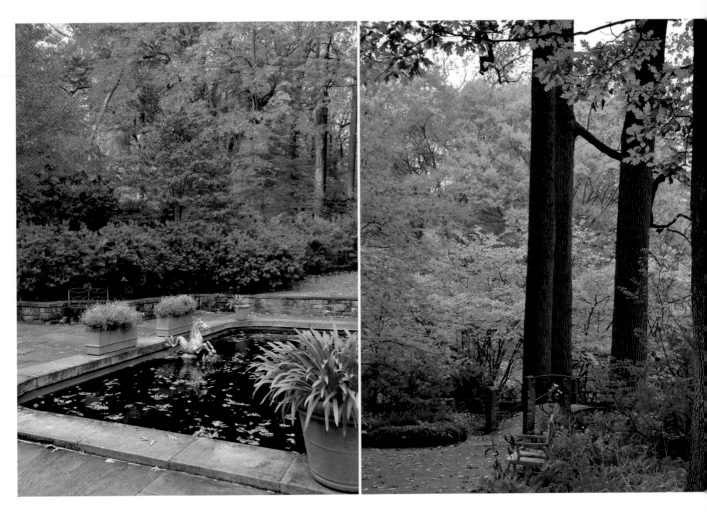

are the yellow papaw tree (*Asimina triloba*) and brilliant yellow witch hazel (*Hamamelis virginiana*), which grow together at the entrance to Enchanted Woods.

For late fall color, Sargent cherries (*Prunus sargentii*) present shades and tints of soft red and apricot after many plants have dropped their leaves. The

Winterhazel Walk becomes a focal point at Winterthur, as the Korean rhododendron (*R. mucronulatum*) produces colors ranging from plum and apricot to burnt orange. Accompanying this display are the golden tints of winterhazels (*Corylopsis* species and cultivars), making the scene a rich tapestry. Nearby a cut-leaf

Japanese maple (*Acer palmatum* var. *dissectum*) is stunning in burnt orange. Meanwhile, giant tulip-poplars, beeches, hickories, and ashes have turned yellow, bronze, and golden tones, brightening our garden walks and inviting us into the woods. ❦

Asian Natives

Viburnum dilatatum and *Callicarpa dichotoma* are but two of the myriad plants in this book that are native to Asia. Asian countries benefited from more favorable conditions during the Ice Ages and thus offer a wealth of plants while many species on other continents perished. Intrepid explorers brought to Europe and North America specimens of these Asian treasures that we enjoy in our gardens. However, we now know that some of these plants are too successful and are harmful to local ecosystems. Several resources are available to determine if a plant is invasive in your area (*www.invasiveplantatlas.org*).

Winterhazel Walk is a tapestry of fall color woven by Korean rhododendron and winterhazels.

Acer rubrum

Acer saccharum

Fall Foliage

In Your Garden

Many native American shrubs and trees are ideal for coloring our fall gardens. Perhaps some of the best shrubs are fothergilla, smooth witherod, and spicebush. Easy to grow and commendable in all seasons, they are superb in the fall. *Fothergilla* provides a rich tapestry of oranges, yellows, and reds while the smooth witherod offers lustrous burgundy leaves. Spicebush brightens the woodlands with its high-spirited yellow foliage. As for trees, *Nyssa sylvatica*, another native, is as beautiful as its name. It colors early and is exceptional at this season. Probably needing no advertising is our flowering dogwood, *Cornus florida*. You could grow the common witch hazel as a small tree or large shrub to enjoy its golden fall foliage and yellow blossoms. All of these plants have stood the test of time at Winterthur, and any would be a fine addition to your fall landscape.

Acer

· Maple
· Sapindaceae

A. palmatum var. *dissectum*

· Cut-leaf Japanese maple

ORIGIN
Japan, China, Korea

ABOUT
Small tree or shrub. Reddish foliage of finely cut leaves turns burnt orange in late fall. Slow growing. Many cultivars.

SIZE
6 – 12' tall
Equal spread
(cultivars may vary)

SOIL
Moist, well drained, acidic

PROPAGATION
Softwood cuttings

SUN
Sun to dappled shade
Zones (5) 6–8

A. rubrum

· Red maple
· Swamp maple

ORIGIN
Eastern U.S.

ABOUT
Deciduous tree. Reddish flowers in earliest spring. Fall color in yellow, orange, red. Tolerates moist soil.

SIZE
40 – 60' tall
Equal spread

SOIL
Moist, slightly acid

PROPAGATION
Softwood cuttings, seeds, many cultivars

SUN
Sun
Zones 3–9

A. saccharum

· Sugar maple

ORIGIN
Eastern Canada and U.S.

ABOUT
Deciduous tree. Greenish yellow flowers in spring, before leaves. Glorious fall coloration, yellow to orange to red. Many cultivars.

SIZE
60 – 75' tall
40 – 60' spread

SOIL
Moist, well drained, fertile, pH adaptable

PROPAGATION
Softwood cuttings

SUN
Sun to partial shade
Zones 4–8

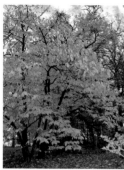 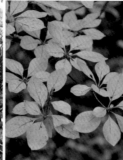 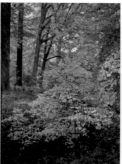

Asimina triloba

· Papaw
· Annonaceae

ORIGIN
Eastern and
Midwestern U.S.

ABOUT
Deciduous tree.
Inconspicuous
purple flowers in
mid-spring. Brilliant
yellow foliage in fall.
Fruit and foliage
colors vary. Pest
free. Transplanting
difficult.

SIZE
15 – 30′ tall
Equal spread

SOIL
Moist, well drained,
fertile, slightly acid

PROPAGATION
Seed

SUN
Sun to partial shade
Zones 5–8

Enkianthus campanulatus

· Redvein enkianthus
· Ericaceae

ORIGIN
Japan

ABOUT
Deciduous shrub or
small tree. Creamy
white, bell-shape
flowers in spring; fall
foliage in shades of
apricot, red, yellow,
and purple.

SIZE
6 – 15′ tall
6′ spread

SOIL
Moist, acidic

PROPAGATION
Seed, cuttings

SUN
Sun to part shade
Zones (4) 5–7

Enkianthus perulatus

· White enkianthus
· Ericaceae

ORIGIN
Japan

ABOUT
Deciduous, rounded
shrub. White,
urn-shape flowers.
Outstanding red
color in fall.

SIZE
4 – 6′ tall
Equal spread

SOIL
Acid, moist,
well drained

PROPAGATION
Seed, cuttings

SUN
Sun to partial shade
Zones 5–7

Lindera benzoin

· Spicebush
· Lauraceae

ORIGIN
Eastern U.S.

ABOUT
Deciduous shrub;
problem free. Graceful
habit. Modest yellow
flowers appear before
leaves. Yellow fall
color. Prune after
flowering.

SIZE
6 – 12′ tall
Equal spread

SOIL
Moist, well drained,
acid but adaptable

PROPAGATION
Seed

SUN
Sun to shade
Zones 4–9

Nyssa sylvatica

· Sour gum, Black gum
· Nyssaceae

ORIGIN
Eastern U.S.

ABOUT
Deciduous tree.
Greenish yellow
flowers bloom with
leaves in spring.
Lustrous foliage turns
red, yellow, orange,
and purple in early
fall. Some cultivars.

SIZE
30 – 50′ tall
20 – 30′ spread

SOIL
Acid, moist,
well drained

PROPAGATION
Difficult, seed

SUN
Sun to partial shade
Zones 4–9

Prunus sargentii

· Sargent cherry
· Rosaceae

ORIGIN
Japan

ABOUT
Handsome, huge
deciduous tree.
Single, white
flowers turn pink
and appear before
leaves. Apricot fall
color.

SIZE
20 – 50′ tall
Equal spread

SOIL
Adaptable

PROPAGATION
Softwood cuttings

SUN
Sun
Zones 4–7

Rhododendron mucronulatum

· Korean
 rhododendron
· Ericaceae

ORIGIN
China, Korea, Japan

ABOUT
Deciduous shrub.
Fall foliage ranges
from plum to apricot
to burnt orange. Rosy
lavender flowers
appear before leaves.
Trouble free. Prune
after flowering.
Several cultivars,
including 'Cornell
Pink.'

SIZE
4 – 8′ tall
Equal spread

SOIL
Acid, moist,
well drained,
organically rich

PROPAGATION
Seed, softwood
cuttings

SUN
Partial shade
Zones 4–7

Stewartia koreana

· Korean stewartia
· Theaceae

ORIGIN
Korea

ABOUT
Deciduous tree.
Excellent fall color.
White cup-shape
flowers in early
summer; round buds.
Trouble free. Little
pruning required.
Cultivars available.

SIZE
20 – 30′ tall
Equal spread

SOIL
Acid, moist,
well drained,
organically rich

PROPAGATION
June cuttings

SUN
Sun to partial shade
Zones 5–7

Fothergilla

· Fothergilla

*For detailed
information,
see "Sundial
Garden," p. 53.*

Hamamelis virginiana

· Common witch hazel

*For details, see
"Berries & Blossoms,"
p. 123.*

Cornus florida

· Flowering dogwood

*For details, see
"Azalea Woods," p. 65.*

Corylopsis Species and Cultivars

· Winterhazel

*For details, see
"Winterhazel
Walk," p. 29.*

Viburnum Species and Cultivars

· Viburnum

*For details, see
"Berries & Blossoms,"
p. 126.*

Pinetum

Broadleaf Evergreens & Bark

WINTER

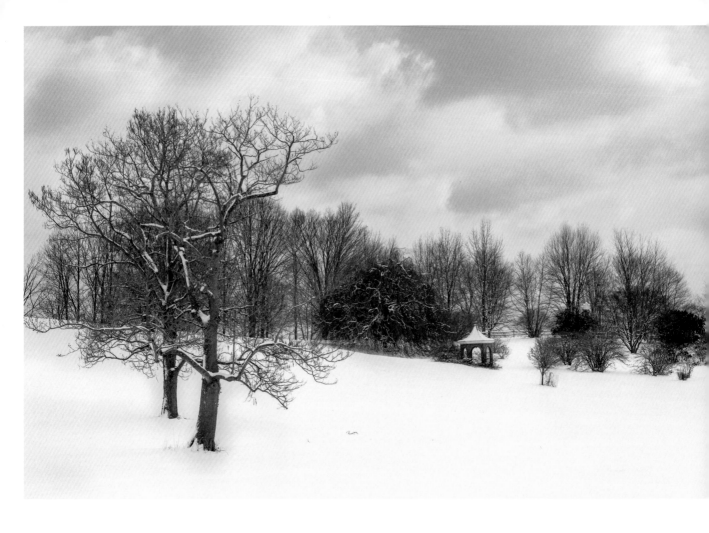

FEW THINGS ARE MORE BEAUTIFUL THAN THE COUNTRYSIDE AFTER
a snowfall. Even without snow, the winter landscape offers structure, sculptural forms,
and color. The Pinetum is a wealth of evergreens that have stood the test of time, and
broadleaf evergreens are used throughout the garden, sometimes for their flowers but
always with an eye to the design effect of their year-round foliage. Likewise, shrubs and
trees that provide early color from flowers or foliage are now showing their ornamental
bark or form.

PINETUM

January to December

As early as 1914, H. F. du Pont and his father decided to establish a Pinetum, a collection of conifers. The majority of these, usually evergreen trees, were planted between 1916 and 1926. Today the Pinetum offers a range of beautiful specimens, creating garden corridors and backdrops. One of the best views of this collection is from a distance, where you can appreciate the different colors, shapes, textures, and sizes. Many of the original trees still exist, and some are rare in the home garden. Among them, the Japanese umbrella pine (*Sciadopitys verticillata*) is noteworthy and is an excellent candidate for a small property. This slow grower features long, glossy needles that maintain their dark green color all winter. The tree is pest free and adds interesting texture to the landscape.

Another conifer to consider is the Japanese cryptomeria (*Cryptomeria japonica*), a graceful, pyramidal tree with soft, feathery texture. Several grow at Winterthur. The beautiful, reddish-brown bark is often visible through the branches. Needles are brighter green in summer than in winter, when they occasionally take on a bronzy hue, especially if affected by wind.

The blue atlas cedar (*Cedrus atlantica* 'Glauca') is a striking conifer that in time becomes much taller and wider than the two trees just mentioned. Although rather open and tending to be pyramidal in adolescence, it matures into a full, rounded tree with silvery blue needles and distinctive texture. Always eye catching, this tree is exceptionally attractive against stone or other gray-tone materials that complement its natural hue. Several Oriental spruces (*Picea orientalis*) have been growing at Winterthur since the 1920s and now tower more than 70-feet tall in the Pinetum. Their branches flow to the ground for a full skirt appearance. This dark green pyramidal tree is an excellent screen or background for flowering shrubs and trees.

Hinoki falsecypress (*Chamaecyparis obtusa*) has also performed well for more than ninety years in the garden. It has gracefully arching sprays of dark green, scale-like leaves, creating a soft, full screen to ground level. The species form is not readily available in

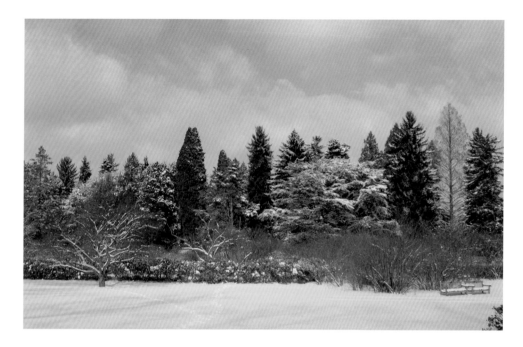

the nursery trade and may be too tall for most home gardens. Two smaller forms, 'Gracilis' and 'Nana Gracilis,' are available at 12 feet and 8 feet, respectively.

One of the last trees that Mr. du Pont added to the Pinetum was a deciduous conifer. In 1948 the Arnold Arboretum first distributed seeds of the dawn redwood (*Metasequoia glyptostroboides*) in the United States. Winterthur planted its two trees in 1951 and 1957 as small specimens. Despite the thirty-year span in planting time, they are already as tall as, or taller than, their older neighbors. Their leafless,

pyramidal form is distinct in the winter landscape.

A 1993 addition to the Pinetum is the Chinese hemlock (*Tsuga chinensis*), a substitute for the Canadian hemlock (*Tsuga canadensis*). It is resistant to the hemlock woolly adelgid, a non-native insect that has killed many of the native American hemlocks. The Chinese species is similar to the Canadian species in having a soft, graceful, full appearance. Both are valuable to the woodland garden because they are shade tolerant. There are also a number of choices if you would like native American conifers. Virginia

The Winterthur Garden Guide: Color for Every Season

red cedar (*Juniperus virginiana*) is a large evergreen shrub that provides a bounty of blue berries for ornament and wildlife. This cedar has separate male and female plants, so you will need both for fruit production. Emerald Sentinel (*J. virginiana* 'Corcorcor') is a columnar female form that holds its green color well in winter. Like Virginia red cedar, eastern arborvitae (*Thuja occidentalis*) is a tall evergreen shrub that requires full sun and is available in a variety of textures, shapes, sizes, and colors. Emerald (*T. occidentalis* 'Smaragd') retains good winter color and offers a smaller option for the home garden.

Two non-native coniferous shrubs thrive in the shade of the towering evergreens of the Pinetum. Japanese plum yew (*Cephalotaxus harringtonia*) resembles yew (*Taxus*) but has the advantage of being less desirable to deer. It holds the color of its dark green leaves throughout the year. In addition to the shrub form (var. *drupacea*), we have added two groundcover forms (*C.* 'Prostrata' and 'Duke Gardens') in place of low-growing yews. Russian arborvitae (*Microbiota decussata*) is another low-growing needled evergreen that has done well in high shade. Its green summer foliage will turn bronze in winter. ⚘

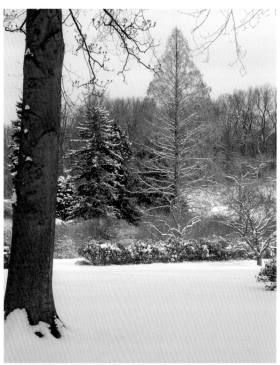

Metasequoia glyptostroboides with male cones provides winter color.

Garden nook created with Chamaecyparis obtusa and evergreen ferns, Dryopteris erythrosora.

Pinetum

In Your Garden

The Winterthur garden offers a small sampling of the conifers available to the home gardener. Sizes range from mere inches to more than 100 feet. They are available in a multitude of green, blue, silver, and yellow shades as well as variegated forms.

Cephalotaxus harringtonia 'Prostrata'

Cedrus atlantica '**Glauca**'

· Blue Atlas cedar
· Pinaceae

ORIGIN
Algeria, Morocco (Atlas Mountains)

ABOUT
Majestic evergreen tree. Outstanding in the landscape. Silvery blue needles.

SIZE
40 – 60' tall
30 – 40' spread

SOIL
Moist, well drained, acid, though pH adaptable

PROPAGATION
Cuttings of firm tip shoots, late fall

SUN
Sun to partial shade
Zones 6–8 (9)

Cephalotaxus harringtonia

· Japanese plum yew
· Cephalotaxaceae

ORIGIN
Japan

ABOUT
Evergreen shrub. Dark green needles, slow growing but shade, heat, and deer tolerant. Can be trained to a tree form.

SIZE
12 – 18' tall
Equal spread

SOIL
Moist, well drained

PROPAGATION
Seeds, cuttings

SUN
Partial to full shade
Zones (5) 6–9

'**Prostrata**'

ABOUT
Dwarf form

SIZE
2 – 3' tall
Equal spread

var. *drupacea*

ABOUT
Spreading shrub

SIZE
6 – 10' tall
Equal spread

'**Duke Gardens**'

ABOUT
Dwarf form

SIZE
2 – 4' tall
Equal spread

 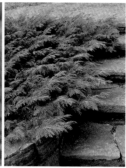

Chamaecyparis obtusa

· Hinoki false cypress
· Cupressaceae

ORIGIN
Japan, Taiwan

ABOUT
Pyramidal evergreen
tree. Full, dark green
scale-like foliage,
reddish brown bark.

SIZE
50 – 100′ tall
15 – 25′ spread

SOIL
Moist, well drained

PROPAGATION
Cuttings

SUN
Sun to partial shade
Zones 4–8

'Gracilis'

ABOUT
Open branched,
pyramidal form.

SIZE
8 – 12′ tall, 4 – 5′ spread

'Nana Gracilis'

ABOUT
Compact, slow-growing

SIZE
6 – 8′ tall, 2 – 4′ spread

Cryptomeria japonica

· Japanese
 cryptomeria
· Cupressaceae

ORIGIN
China, Japan

ABOUT
Pyramidal evergreen.
Graceful sprays of
green needles in
summer; may bronze
in winter in windy
sites. Easy.
Many cultivars.

SIZE
50 – 60′ tall
20 – 30′ spread

SOIL
Acid, moist, well
drained, light

PROPAGATION
Cuttings in November

SUN
Sun to partial shade
Zones (5) 6–8

Juniperus virginiana

· Eastern red cedar
· Cupressaceae

ORIGIN
Eastern and Central
North America

ABOUT
Large evergreen
shrub/tree. Tolerant
to drought, heat and
cold.

SIZE
40 – 50′ tall
8 – 20′ spread

SOIL
Moist, well drained
but tolerant of
adverse sites

PROPAGATION
Seed, cuttings

SUN
Sun
Zones 2–9

'Corcorcor'
Emerald Sentinel

ABOUT
Female form that
holds good color.

SIZE
15 – 20′ tall
4 – 6′ spread

Metasequoia glyptostroboides

· Dawn redwood
· Cupressaceae

ORIGIN
China

ABOUT
Deciduous conifer.
Fast-growing
pyramidal tree,
russet red fall foliage.

SIZE
70 – 100′ tall
25′ spread

SOIL
Moist, well drained,
slightly acidic,
tolerant of wet areas

PROPAGATION
Seed, softwood
cuttings

SUN
Sun
Zones (4) 5–8

Microbiota decussata

· Russian arborvitae
· Cupressaceae

ORIGIN
Southeastern Siberia

ABOUT
Low-arching
evergreen shrub.
Green, lacy foliage in
spring and summer
that will turn bronze
color in winter. Rarely
damaged by deer and
tolerant of high shade.

SIZE
1′ tall
3 – 12′ spread

SOIL
Moist, well drained

PROPAGATION
Cuttings

SUN
Sun to partial shade
Zones 3–7

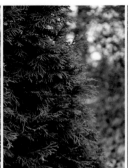

Picea orientalis

· Oriental spruce
· Pinaceae

ORIGIN
Caucasus to Turkey

ABOUT
Pyramidal evergreen. Excellent dark green screen or background tree because it holds its lower branches.

SIZE
50 – 70′ tall
15 – 25′ spread

SOIL
Moist, well drained

PROPAGATION
Seed

SUN
Sun to partial shade
Zones 4–7

Sciadopitys verticillata

· Japanese umbrella pine
· Sciadopityaceae

ORIGIN
Japan

ABOUT
Slow-growing evergreen. Long, glossy, dark green needles retain color throughout winter. Unusual texture. Pest free.

SIZE
20 – 30′ tall
15 – 20′ spread

SOIL
Acid, moist, well drained, organically rich

PROPAGATION
Winter or summer cuttings

SUN
Sun
Zones 5–7

Thuja occidentalis

· Eastern arborvitae
· Cupressaceae

ORIGIN
Eastern North America

ABOUT
Large evergreen shrub or tree. Numerous cultivars available from 2 to 20′ tall, colors from yellow, cream, green, and variegated forms.

SIZE
40 – 60′ tall
10 – 15′ spread

SOIL
Moist, well drained, tolerant of limestone

PROPAGATION
Cuttings

SUN
Sun, Zones 3–7

'Smaragd' Emerald

ABOUT
Narrow pyramidal form with good green winter color.

SIZE
10 – 15′ tall
3 – 4′ spread

Tsuga canadensis

· Canadian hemlock
· Pinaceae

ORIGIN
North America

ABOUT
Large evergreen tree. Elegant arching branches, shade tolerant, cultivars available in different shapes and sizes.

SIZE
40 – 70′ tall
25 – 35′ spread

SOIL
Moist, well drained

PROPAGATION
Seed, cuttings

SUN
Sun to shade
Zones 3–7 (8)

Tsuga chinensis

· Chinese hemlock
· Pinaceae

ORIGIN
China

ABOUT
Evergreen tree. Elegant arching branches. Shade tolerant and resistant to the hemlock woolly adelgid.

SIZE
80 – 150′ tall
30′ spread

SOIL
Moist, well drained

PROPAGATION
Seed

SUN
Sun to shade
Zones 5–7

BROADLEAF EVERGREENS & BARK

January to December

Broadleaf Evergreens

Broadleaf evergreens can be valuable additions to the garden for their flowers as well as foliage. Their full form is an asset in creating garden spaces or screening unwanted views. The dark green foliage is an ideal background for highlighting any flower color and is a striking contrast to the warm colors of autumn foliage. In winter, the solid broad leaves provide color and textural contrast against the varied colors and textures of the needle-leaf conifers.

In addition to the broadleaf rhododendrons, pieris, and camellias mentioned earlier, the following shrubs add year-round green to the garden. Drooping leucothoe (*Leucothoe fontanesiana*) is an elegant low-arching shrub that is native to the eastern United States. It is a good choice for shady banks, where it will slowly spread to hold the soil. Cherry laurel (*Prunus laurocerasus*) will also thrive in shade. It has a more horizontal or upright profile.

Holly osmanthus (*Osmanthus heterophyllus*) provides more height

and spiny leaves. It is often mistaken for holly because of the similarities of their leaves, but unlike holly, the leaves are opposite on the branches, and it has fragrant flowers in the fall. The small, white flowers are not especially showy, but their sweet fragrance deserves a location where you walk daily. Leatherleaf mahonia (*Mahonia bealei*) is similar in size to holly

Dark green leaves of Mahonia bealei and red flower buds of Pieris japonica 'Forest Flame' mark the entrance to the Quarry Garden.

Ilex opacca 'Clarissa' adds a yuletide touch at the museum.

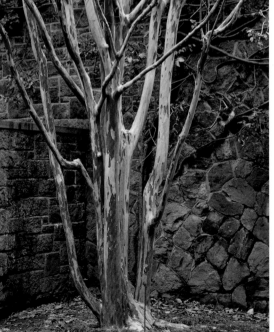

A winter display features the many shades of brown in the bark of Lagerstroemia 'Natchez.'

osmanthus but has larger spring leaves that provide textural interest year-round. For taller broadleaf evergreens, look to magnolias. Sweetbay magnolia (*Magnolia virginiana*) will be evergreen to semi-evergreen in its southern range but deciduous in colder climates. Southern magnolia (*M. grandiflora*) provides more height and year-round foliage.

Hollies

Hollies are a rich source of broadleaf evergreens; they offer many sizes, shapes, and textures and maintain their good looks year-round. In December they really come into their own, when many display brilliant red, orange, or yellow berries. With few exceptions, hollies are dioecious so you will need to select male and female cultivars for berry production. Hollies can thrive in sunny as well as shady spots. Several species and hundreds of cultivars are available, and there is one suitable for nearly every purpose in a wide range of climates.

Winterthur features American holly (*Ilex opaca*) throughout the garden. Its tall evergreen form helps screen the buildings. The holly berries are a welcome bonus for their Yuletide color and are favorite for wildlife. 'Jersey Princess' and 'Satyr Hill' are valued for their long-lasting red berries that

hold well into winter. 'Miss Helen' is slow growing and therefore develops a dense habit. It also has a good red berry display.

Japanese holly (*Ilex crenata*) is typically a lower shrub grown specifically for its evergreen foliage. We have used 'Bennett's Compacta' as an easy-care substitute for boxwood. You can consider cultivars of inkberry (*Ilex glabra*) for this role if you prefer a native alternative. Not all hollies are evergreen. Our native deciduous holly (*Ilex verticillata*) began displaying its berries in the fall providing a contrast with yellow autumn foliage. The red, orange, or yellow berries will hold well through the Yuletide season. They are a great addition to the garden for both their outdoor and indoor display. Since holly berries form on the current year's growth, the branches are valuable for decorative purposes on both evergreen and deciduous types.

Deciduous Trees

The bark and branching patterns of deciduous trees can also be assets in the winter garden. Paperbark maple (*Acer griseum*) is arresting at this season, with cinnamon-color exfoliating bark and fine architecture. This handsome tree makes an excellent specimen plant. Several shrubs and small trees described earlier for their flowers, fruit, and fall foliage also offer attractive bark and winter form. As they age, the bark of the Kousa dogwood (*Cornus kousa*), Japanese stewartia (*Stewartia pseudocamellia*), and Korean stewartia (*Stewartia koreana*) develop a patchwork of exfoliating swatches of greens, oranges, browns, and grays. The many cultivars of crape myrtles offer a range of bark colors and textures. Natchez crape myrtle (*Lagerstroemia* cv. Natchez) is valued for its rich cinnamon-color bark as much as its summer flowers. The fragrant snowbell (*Styrax obassia*), noted for its flowers and fruit, creates a strong upright sculpture of smooth gray branches. American hornbeam (*Carpinus caroliniana*) has several common names that evoke this same strength: ironwood and musclewood. These names are descriptive of its hard wood and gray, sinewy looking bark. This shade-tolerant small tree will perform well in the woodland garden.

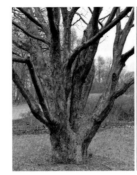 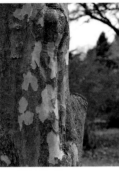

In Your Garden

Any of these plants will add color to your landscape during the winter season. Some are common, others less so, but all are relatively easy to grow. The evergreens provide structure throughout the year and backdrops for the colorful bark and sculptural forms of small trees. Watch for witch hazels and snowdrops that are eager to start the new cycle of color.

Acer griseum

· Paperbark maple
· Sapindaceae

ORIGIN
China

ABOUT
Vase-shape deciduous tree. Cinnamon-color exfoliating bark; excellent fall foliage.

SIZE
20 – 30' tall
15 – 20' spread

SOIL
Moist, well drained, pH adaptable

PROPAGATION
Difficult, softwood cuttings

SUN
Sun to partial shade
Zones 5–7 (8)

Carpinus caroliniana

· American hornbeam
· Betulaceae

ORIGIN
Eastern North America

ABOUT
Deciduous small tree. Smooth gray bark, yellow to orange-red fall foliage.

SIZE
20 – 35' tall
Equal spread

SOIL
Moist, well-drained but will tolerate periodic flooding and drier sites

PROPAGATION
Seeds

SUN
Partial to full shade
Zones 3–9

Cornus kousa

· Kousa dogwood

For detailed information, see "Sycamore Hill," p.91.

Ilex

· Holly
· Aquifoliaceae

ABOUT
Evergreen and deciduous shrubs or trees. Prune at any time of year.

PROPAGATION
Softwood cuttings

I. crenata

· Japanese holly

ORIGIN
Japan, Korea, China

ABOUT
Evergreen shrub. Small, glossy leaves. Select cultivars for size and form.

SIZE
8 – 12′ tall
Equal spread

SOIL
Moist, well drained, and slightly acid

SUN
Sun or shade
Zones (5) 6–7 (8)

I. crenata 'Bennett's Compacta'

ABOUT
Compact form.

SIZE
3 – 4′ tall
4 – 5′ spread

SUN
Zones 5–7

I. glabra

· Inkberry

ORIGIN
Eastern North America

ABOUT
Evergreen shrub. Small, glossy evergreen leaves. Select cultivars for fuller plant.

SIZE
4 – 6′ tall
Equal spread

SOIL
Acid, can be damp, adaptable

SUN
Sun or shade
Zones 4–9

I. opaca

· American holly

ORIGIN
Eastern U.S.

ABOUT
Large shrub or tree. Evergreen foliage; red berries (female plants) in early winter. Slow growing. Many excellent cultivars.

SIZE
15 – 30′ tall
10 – 20′ spread

SOIL
Moist, well drained, acid

SUN
Sun to partial shade
Zones 5–9

'Satyr Hill'

ABOUT
Large red fruit, excellent berry retention.

SIZE
30 – 40′ tall
15 – 25′ spread

'Clarissa'

ABOUT
Extremely hardy form with dark green winter foliage.

SIZE
30′ tall
15′ spread

'Jersey Princess'

ABOUT
One of finest fruiting forms, holds red fruit into winter.

SIZE
35′ tall
25′ spread

'Miss Helen'

ABOUT
A low growing with dense form, red fruit.

SIZE
15 – 25′ tall
10 – 18′ spread,
6 – 8′ in ten years

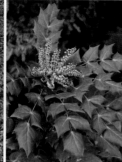
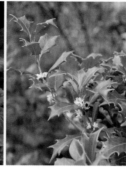

Stewartia koreana

Leucothoe fontanesiana

· Drooping leucothoe
· Ericaceae

ORIGIN
Southeastern U.S.

ABOUT
Evergreen shrub.
White, fragrant,
slender urn-shape
flowers in spring.

SIZE
3 – 6′ tall
3 – 6′ spread

SOIL
Acid, moist, well
drained, organic

PROPAGATION
Seed, cuttings

SUN
Partial to full shade
Zones (4) 5–8

Mahonia bealei

· Leatherleaf mahonia
· Berberidaceae

ORIGIN
Western China

ABOUT
Evergreen shrub.
Yellow flowers in late
winter, early spring.
Attractive blue fruit.
Naturalized in parts
of the U.S.

SIZE
4 – 10′ tall
3 – 8′ spread

SOIL
Moist, well drained

PROPAGATION
Seed, cuttings

SUN
Partial to full shade
Zones 7–9

Osmanthus heterophyllus

· Holly osmanthus
· Oleaceae

ORIGIN
Japan

ABOUT
Evergreen shrub.
White, fragrant
flowers during fall.
Spiny leaves when
the plant is young.

SIZE
8 – 10′ tall
7 – 9′ spread

SOIL
Moist, well-drained,
acidic soil

PROPAGATION
Cuttings

SUN
Sun to shade
Zones 6–9

'Gulftide'

ABOUT
Cold-hardy cultivar.

Prunus laurocerasus

· Cherry laurel
· Rosaceae

ORIGIN
Southeastern Europe
to Asia Minor

ABOUT
Evergreen shrub.
Dense with large,
lustrous, dark
green leaves. White
fragrant flowers in
spring. Cultivars
available for cold
hardiness, size,
and leaf color.

'Schipkaensis'

ABOUT
Cold-hardy cultivar.

SIZE
10 – 18′ tall
20 – 25′ spread

SOIL
Moist, well drained,
organic

PROPAGATION
Seeds; late summer
cuttings

SUN
Partial to heavy shade
Zones 5–8

Stewartia

*For detailed
information, see
"Sycamore Hill"
and "Fall Foliage,"
p. 94, 132.*

Styrax obassia

· Fragrant snowbell

*For details, see
"Berries & Blossoms,"
p. 125.*

Select References

Armitage, Allan M. *Armitage's Manual of Annuals, Biennials, and Half-Hardy Perennials*. Portland, Ore.: Timber Press, 2001.

Herbaceous Perennial Plants: A Treatise on Their Identification, Culture, and General Attributes. 2nd ed. Champaign, Ill.: Stipes Publishing, 1997.

Bruce, Harold. *Winterthur in Bloom*. New York: Chanticleer Press, 1986.

Cullina, William. *New England Wildflower Society Guide to Growing and Propagating Wildflowers of the United States and Canada*. Boston: Houghton Mifflin, 2000.

Culp, David L. *The Layered Garden: Design Lessons for Year-Round Beauty from Brandywine Cottage*. Portland, Ore.: Timber Press, 2012.

Darke, Rick. *The American Woodland Garden: Capturing the Spirit of the Deciduous Forest*. Portland, Ore.: Timber Press, 2002.

Darke, Rick, and Douglas W. Tallamy. *The Living Landscape: Designing Beauty and Biodiversity in the Home Garden*. Portland, Ore.: Timber Press, 2014.

Dirr, Michael A. *Dirr's Hardy Trees and Shrubs: An Illustrated Encyclopedia*. Portland, Ore.: Timber Press, 1998.

Manual of Woody Landscape Plants: Their Identification, Ornamental Characteristics, Culture, Propagation, and Uses. 5th ed. Champaign, Ill.: Stipes Publishing, 1998.

Druse, Ken. *The New Shade Garden: Creating a Lush Oasis in the Age of Climate Change*. New York: Abrams, 2015.

Fiala, Fr. John L. *Lilacs: The Genus Syringa*. Portland, Ore.: Timber Press, 1988.

Fleming, Nancy. *Money, Manure, and Maintenance*. Weston, Mass.: Country Place Books, 2005.

Frederick, William H. Jr. *The Exuberant Garden and the Controlling Hand: Plant Combinations for North American Gardeners*. Boston: Little, Brown, 1992.

Galle, Fred C. *Azaleas*. Rev.ed. Portland, Ore.: Timber Press, 1995.

Lord, Ruth. *Henry F. du Pont and Winterthur: A Daughter's Portrait*. New Haven: Yale University Press, 1999.

Magnani, Denise, et al. *The Winterthur Garden: Henry Francis du Pont's Romance with the Land*. New York: Harry N. Abrams, 1995.

Poor, Janet, and Nancy Peterson Brewster. *Shrubs. Vol. 2 of Plants that Merit Attention*. Portland, Ore.: Timber Press, 1996.

Rainer, Thomas, and Claudia West. *Planting in a Post-Wild World: Designing Plant Communities for Resilient Landscapers*. Portland, Ore.: Timber Press, 2015.

Robinson, William, and Rick Darke. *The Wild Garden: Expanded Edition*. Portland, Ore.: Timber Press, 2009.

Slade, Naomi. *The Plant Lover's Guide to Snowdrops*. Portland, Ore.: Timber Press, 2014.

Smith, W. Gary. *From Art to Landscape: Unleashing Creativity in Garden Design*. Portland, Ore.: Timber Press, 2010.

Tai, Lolly. *The Magic of Children's Gardens*. Philadelphia: Temple University Press, 2017.

Tallamy, Douglas W. *Bringing Nature Home: How You Can Sustain Wildlife with Native Plants*. Portland, Ore.: Timber Press, 2007.

Thomas, William R. *The Art of Gardening: Design Inspiration and Innovative Planting Techniques from Chanticleer*. Portland, Ore.: Timber Press, 2015.

Van Beck, Sara L. *Daffodils in American Gardens, 1733–1940*. Columbia: University of South Carolina Press, 2015.

Vivian, John. *Building Stone Walls*. Pownal, Vt.: Garden Way Publishing, 1978.

Glossary

Bract A modified leaf below a flower, often resembling a petal

Bulb An underground storage organ consisting of modified stem and fleshy leaves (daffodils)

Bulbil A small bulb arising around the parent bulb; when detached, it will form a new plant

Bulblet A small bulb arising in a leaf axil; when detached, it will form a new plant

Calyx The sepals as a group, directly under petals

Clone Vegetatively produced progeny of a plant

Corm Bulblike underground swollen stem with scaly leaves (crocus)

Cormel A small corm formed at the base of a parent corm; when detached, it will form a new plant

Corolla The petals as a group

Corona Tubular structure on the inner side of petals, such as the trumpet of a daffodil

Corymb Flat-top inflorescence in which flowers are held on stems of different lengths

Cultivar A named plant, vegetatively produced (a named clone)

cv. Abbreviation for cultivar

Dioecious Male and female flowers on separate plants

Exfoliating Naturally peeling (bark)

Fall The outer petals of an iris

Habit Characteristic form and mode of growth of a plant

Hose-in-hose One corolla inside another, appearing to be one blossom inside another

Hybrid Offspring of breeding two plants of different species, varieties, or cultivars

Indicum Late-blooming Japanese rhododendron species

Inflorescence Cluster of individual flowers arranged in a specific order

Offset Small bulb or plant produced by the parent plant; when separated, will form a new plant

Palmate Having sections radiating from a common point

Panicle Inflorescence with branching of flowers on pedicels along an axis

Pedicel The stalk of a flower

Raceme Inflorescence in which flowers are hold on stalks along an elongated axis

Rhizome An underground modified stem, often fleshy

Rugose Rough, with impressed veins

sbsp. Abbreviation for subspecies, a division of a species

Sepal A leaflike division of the calyx (outer covering of a flower, directly below the petals)

Species A group of individuals having common characteristics, distinct from other groups; the basic unit of botanical classification

Spike Inflorescence in which unstalked flowers are held on an elongated axis

Sport A branch with characteristics different from the rest of the plant; for example, flowers of a different color

ssp. Abbreviation for species (plural)

Standard Inner petals of an iris flower, usually held erect

Stoloniferous Producing underground shoots

Subspecies Group within a species showing minor differences

Tepal Segment of a flower where the corolla and calyx are undifferentiated; as in magnolia

Triploid Containing three times the usual complement of chromosomes

Tuber Swollen rhizome

Umbel Flat-top inflorescence in which all flower stalks arise from a single point

var. Abbreviation for variety

Variety A subdivision of a species, varying from others in a minor way

Whorl Group of leaves or flowers arising at one level around the stem

Index

Italicized page numbers indicate illustrations.